IMAGES
of America
OAK PARK

Happy Father's Day!
— Danny & Joe

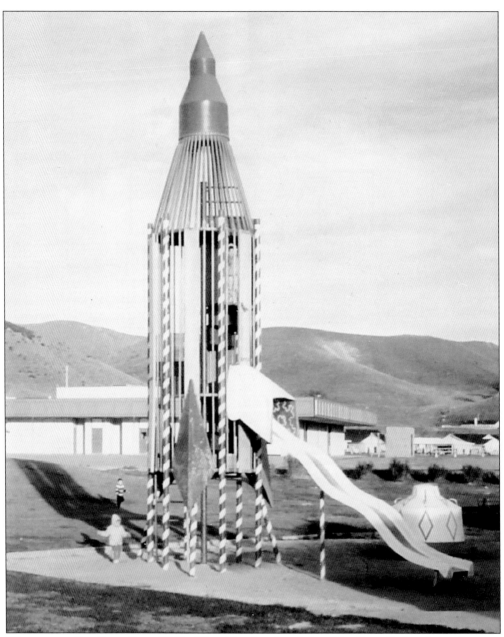

WELCOME TO OAK PARK, LATE 1960s. The old rocket ship slide at Mae Boyar Park welcomed visitors to the area as early as the mid-1960s. The developer called this spot a "space age" playground, a nod to the Rocketdyne plant in the northwestern section of the Simi Hills where some of the early Oak Park residents worked. Also pictured in the photograph are Brookside Elementary School, the rolling hills of Oak Park, and four-year-old Ilana Kern. (Photograph by Harvey Kern.)

ON THE COVER: Oak Park pioneer Barbara De Minico and her daughters Sharon (left) and Paula stand in front of their 1960s station wagon and newly acquired home in the remote hill-country community. (De Minico Family Archives.)

IMAGES of America
OAK PARK

Harvey Kern, David E. Ross,
Derek Ross, and Harry Medved

Photo Editor: Brian Rooney

Copyright © 2012 by Harvey Kern, David E. Ross, Derek Ross, and Harry Medved
ISBN 978-0-7385-9538-2

Published by Arcadia Publishing
Charleston, South Carolina

Printed in the United States of America

Library of Congress Control Number: 2011942200

For all general information, please contact Arcadia Publishing:
Telephone 843-853-2070
Fax 843-853-0044
E-mail sales@arcadiapublishing.com
For customer service and orders:
Toll-Free 1-888-313-2665

Visit us on the Internet at www.arcadiapublishing.com

*For their patience, support, and love,
this book is dedicated to our families:
Michele, Shoshana, and Aviva Medved;
Ann C. Hayman, Ilana Ormand, and Carla Ronk;
Evelyn, Allen, and Heather Ross;
and Lauren, Molli, and Elli Ross.*

Contents

Acknowledgments		6
Introduction		7
1.	This Land Was Their Land: Dwellers, Settlers, and Builders	9
2.	Welcome to the Country: The Road to Oak Park	25
3.	From the Ground Up: Early Development	39
4.	School Days: The Birth of a District	59
5.	The Hills Are Alive: Parks, Recreation, and Trails	79
6.	Our Town and Cultural Life: Celebrations and Institutions	105
7.	Hollywood West: Movies Filmed in Oak Park and Environs	119

Acknowledgments

The authors gratefully thank the current and former residents of Oak Park and the surrounding environs for sharing their memories and classic images.

We would also like to thank several unsung heroes who helped bring this book to completion. Corporate presentations designer, photographer, author, and historian Brian Rooney was involved in helping produce every page of this history. Rooney's photographic guidance, scanning, and research work were instrumental in the success of this book. Writer Bruce Akiyama offered his knowledge of film lore and provided substantial input throughout the manuscript. The brilliant local photographer Ed Lawrence graciously provided his remarkable vintage photographs of the area and his invaluable memories of the locations. Photographer Greg Tucker made several trips to Oak Park's natural areas for many of the images in this book. Oak Park veteran Marc Franklin of Franklin Video Productions, Inc., supplied his advice, professionalism, and visual expertise through the wee hours of the night, along with key video analysis and digital image research. *Los Angeles Times* reporter Bob Pool, who has written newspaper stories about Oak Park for more than three decades, graciously provided us with his clips, photographs, and classic stories. Laurie Dunning of the Oak Park Library helped us discover many significant findings and helped spread the word about our desire to build an Oak Park History Archives. Colleen Janssen and Renee Peace of Rancho Simi Recreation and Park District found historical photographs and plans for the parks and trails. Simi Valley Trailblazers leader Mike Kuhn, who helped build many of the trails in Oak Park, identified many of the natural landmarks of the hills. Jeanette Berard and Klaudia Englund at the Special Collections Department of the Thousand Oaks Library, Mark A. Lunn and Lawrence Lee at the County Clerk and Recorder's Office of Ventura County, and Carolyn Phillips of the Simi Valley Historical Society helped us extensively with our research. Oak Park pioneers Barbara and Dan De Minico shared their amazing collection of photographs and wonderful stories of Oak Park in the 1960s.

A tale of two families, the Jordans and Boyars, was constructed with the generous time, advice, and photographs of their descendants. Jim and Marian Jordan's granddaughters Molly Jordan Koch and Janice Jordan and Lou and Mae Boyar's granddaughters Karen E. Kennedy and Julie Goodman Aharoni were instrumental in uncovering the early history of Oak Park's pioneers and their beloved land.

Additionally, the following folks helped fill in the missing gaps in Oak Park history: Ronald Stark, the first chair of the Oak Park Municipal Advisory Council; Pat Manning, the founding mother of the Oak Park Unified School District, along with superintendent Dr. Tony Knight, Julie Suarez, and Linda Sheridan; Lakewood historian D.J. Waldie; Oak Park planner Richard W. Smith; mapmaker Gary Liss; local Native American expert Tom Boles; Janna Orkney, Mary Wiesbrock, Supervisor Linda Parks, and Jan Osterhaven for their history of the open space; Mike, Alyce, and Lynn Nine; Ursula Dietel; John Perry; Lorin Michel; Pascal Menut; Brent Davis; Marc Wanamaker; Lynn Lawrence; Spencer Resnick; Sheila and Wick Irwin; Glen Wilcox; Ron Latimore; Tom Reyes; Chad and Lorie Hampton; Andy and Cynthia Gill; Russell and Julie Paris; Eileen Kahn; Melody Rafelson; Robyn Flans; John Loesing; Sylvie Belmond; Allan and Karen Shoff; the late Pat Allen; Jim Bass; Barbara Preston; Barbara Bietz; Jason Burke; Rob and Irene Prushan; Tinsley Yarbrough; Jan and Steve Iceland; Anthony Bledin; Dr. Michael Glassow; Robyn Britton of Ladyface Alehouse; Steve Wong of the Chinese American Museum; Miriam Sprankling of the Stagecoach Inn Museum; Jeff Pirtle of Universal Studios Archives; Charles Johnson of the Ventura County Museum of History; and Amy Wong of UCLA Special Collections.

We would also like to thank Jerry Roberts, who initiated this project, our incredible team at Arcadia Publishing—Kristie Kelly, Teresa Simmons, Debbie Seracini, and Mike Litchfield—and most of all, our faithful editor Amy Perryman. We thank them for their guidance and encouragement.

INTRODUCTION

The community of Oak Park is located in southeastern Ventura County. It is bordered on the west by the North Ranch neighborhood of Thousand Oaks and on the south by the cities of Agoura Hills and Westlake Village in Los Angeles County. It is bounded on the east and north by a portion of the Santa Monica Mountains National Recreation Area.

Oak Park's history dates back to 1966. It was built by Louis Boyar, a developer who worked on homes for defense-plant workers in Southern California during World War II. In 1947, he teamed up with now-legendary developers Mark Taper and Ben Weingart to create Lakewood, the nation's first planned post–World War II "contract city," located south of downtown Los Angeles and just east of the Long Beach city limits. Some historians say they "forever altered the map of Southern California."

A model community for future suburbs, Lakewood was the largest city ever developed by a single builder at the time. It consisted of 17,500 homes built on 3,375 acres of bean farmland "offering good value at a relatively low price." Subsequently, Lou Boyar teamed with his brother Mark Boyar to form the Metropolitan Development Corporation (MDC), which eventually became a publicly held company. The Boyars applied their skills for planned communities and projects in the San Fernando Valley, and among their projects are West Hills (built as Valley Park Highlands on the remote Platt dairy ranch), Sunkist Gardens in Woodland Hills, and the Fallbrook Square Shopping Center.

Meanwhile, while the Boyars were involved in development, one of the most famous radio duos in history were enjoying the fruits of their long broadcasting careers. Jim and Marian Driscoll Jordan, known to the world as "Fibber McGee and Molly," were among the top radio stars of their time. They acquired a huge 5,700-acre ranch in Ventura County, part of the rural community of Agoura, and built their ranch home in the middle of it, just north of the present site of Oak Park High School.

When the Boyars and MDC decided to take their development talent farther north and west, they were able to acquire 2,665 acres of the Jordans' ranch and named their newly planned community "Oak Park."

Advertisements for the isolated community began to appear in the *Valley News and Green Sheet* (now the *Daily News*). The original brochure called it, "The new plan for living designed for you . . . A completely new community in the rolling hills adjacent to the Ventura Freeway." The Ventura Freeway was west of the Las Virgenes Road exit and a two-lane country highway with no center divider.

The brochure went on to extol the design for "modern Los Angeles Megalopolis living, with complete shopping, schools, and recreational facilities . . . a ten-acre school site, six-acre park, and 18-hole golf course already under development in the first unit of the community." The golf course was never built.

The homes featured "underground utilities, street lights, wide sidewalks, 'extras,' and many interior design features." All were approved by the Federal Housing Authority (FHA).

The original Oak Park homes were located on Kanan Road, Birchwood, Oakleaf, and Pinewood Avenues, Tamarind Street, and Satinwood Avenue and sold for $23,000. In 1968, the second unit included Maplegrove Street and Smoketree Avenue. The third unit was completed in 1972 and included Pinion Street, Bayberry Street, and Joshua Street. Others followed this design, and eventually the west side of Kanan was also developed. Original homeowners would later benefit from California's 1978 Proposition 13, which held property taxes down for the next 30 years.

The community attracted hundreds of buyers from the San Fernando Valley and beyond. Traveling to Canoga Park, which the *Los Angeles Times* in 1966 called the home of "the growing space-age light industrial complex," was easy and took only about 15 minutes.

New MDC leadership initiated a new planning and designing effort for the remaining Oak Park parcels to the north and west. The new plan, approved in 1974, showed Kanan Road extending once again from Tupelo Street (later renamed Sunnycrest Drive) to serve new development towards the Lindero Canyon area. Development continued until the Sutton Valley, a bowl-shaped valley located to the north and west, was full. Ventura County monitored the building closely and did not permit homes to be built atop ridgelines. With the construction of the final Chambord Homes by Pardee Development in 2002, Oak Park was at last built out. The final new homes were priced at over $1 million, and the value of most well-maintained original homes exceeded $600,000. With no further development possible, the open spaces within and surrounding this beautiful community will remain forever as dedicated parklands.

Oak Park is the largest unincorporated community in Ventura County. At one point, an advisory vote was taken to determine if residents preferred to (a) annex to the City of Thousand Oaks, (b) become an independent incorporated city, or (c) remain unincorporated. The community felt that remaining unincorporated best met its needs. For many years, the Oak Park Civic Association dealt with community issues. In the 1970s, the Ventura County Board of Supervisors authorized creation of the Municipal Advisory Council (MAC). By California law, the elected MAC members officially represent the community to the Ventura County Board of Supervisors, generally overseeing matters affecting the community.

The Community Foundation for Oak Park is a nonprofit umbrella organization that raises funds to help support community activities and oversees a number of organizations whose volunteers serve the residents of Oak Park.

Oak Park has three business or shopping centers. The original, compact Oak Park commercial center was located at the southeast corner of Sunnycrest Drive and Kanan Road and opened in the 1970s. The Oak Park Shopping Center, located at the southeast corner of Kanan and Lindero Canyon Roads, opened in the 1990s and featured a large supermarket and a variety of other retail stores, restaurants, and services. A third shopping center, Oak Park Plaza, opened on the northeast corner of Kanan and Lindero Canyon Roads, also with restaurants and services.

Today, the community of Oak Park has 5,200 homes, apartments, and condominiums for its 14,300 residents. If land and home prices are any indication, it is one of the most desired communities in which to live, work, raise families, and play.

One

THIS LAND WAS THEIR LAND

Dwellers, Settlers, and Builders

For several thousand years, the occupants of the land were the Chumash Indians. These Native Americans lived simply by hunting, gathering, and trading. The Chumash occupied lands from the Malibu area of the Pacific Ocean to San Luis Obispo County. A Chumash museum is located near Oak Park.

In the 1700s, Spanish explorer Gaspar de Portola traveled through the territory. The king of Spain created land grants throughout the area. What is now Oak Park was part of Rancho Simi, adjacent to Rancho Las Virgenes to the south and Rancho El Conejo to the west.

Various stories of area settlers persist. Leonis Adobe historian Laura B. Gaye claimed in 1979 that "the present location of the Oak Park development was the old homesite of the Agoure family" after whom Agoura was named.

Over time, media giant William Randolph Hearst acquired a wide swath of neighboring Spanish land grant ranch properties. A portion of Hearst's land was eventually purchased by radio stars Jim and Marian Jordan. Their ranch house was located just north of the current site of Oak Park High School.

Marian Jordan was ailing by the late 1950s, and she was unable to enjoy the ranch property as she once did. Jim Jordan sold portions (China Flat, Palo Comado) to fellow entertainer Leslie Townes "Bob" Hope. In the ensuing years, Jordan sold the rest of their ranch. Builders Lou and Mark Boyar and their Metropolitan Development Company purchased and developed this last parcel as Oak Park.

"As a kid, I would rocket through my grandparents' ranch, greeting the baby animals—the calfs and the foals—while running off to admire the stunning vistas," recalls Molly Jordan of her visits to the Jordan family getaway. "They were humble Irish folk from Peoria who had a magical connection to the land, with deep roots in nature. Their cattle ranch was a sanctuary for all of us."

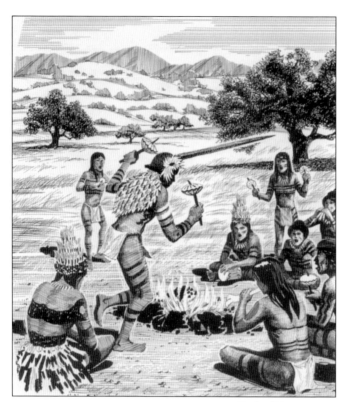

CHUMASH INDIANS. Among the first known occupants of the area were the Chumash Indians and their predecessors, whose reach stretched from Malibu Canyon to San Luis Obispo and who hunted and gathered food in Oak Park. According to noted archaeologist Dr. Michael Glassow, who worked on a dig here in the 1960s, the Oak Park destination was ideal due to "a confluence of resources: fresh water, acorns for grinding into cakes or mush, and good rabbit-hunting." (Los Angeles Public Library/Agoura Hills Branch.)

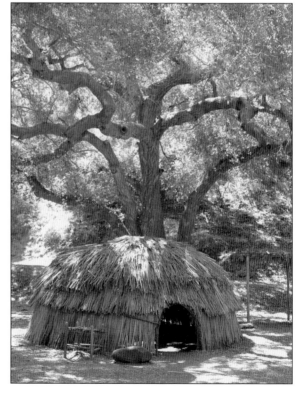

THERE'S AN AP FOR THAT. These circular, domed structures were called *aps* and were put together with branch-pole supports covered with tule or reed thatch. This reconstructed ap has been a favorite play area and school field trip destination for local kids. It is located in a shady oak canyon at the Chumash Indian Museum complex, which is not far from Kanan Road and Westlake Boulevard and just a few miles away from Oak Park. (Ken Lubas/Chumash Indian Museum.)

CHUMASH INDIAN CAVE PAINTINGS. Although this painting is not located in Oak Park, it is located nearby in Simi Hills. Photographer Mike Kuhn called these specific drawings "among the best preserved Indian pictographs in Southern California." He notes, "This polychromatic Chumash rock art possibly depicts the mythological Coyote climbing a medicine ladder to the spirit world, with a centipede hitching a ride on his back." (Mike Kuhn.)

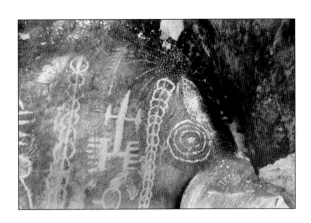

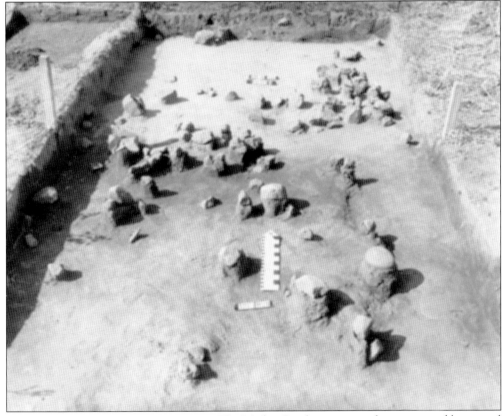

OAK PARK INDIAN EXCAVATIONS, 1966. The Medea Creek region was first excavated by several local college archaeology classes, the most noted being under the auspices of UCLA. At the La Robleda (Spanish for "little oak grove") excavation site, UCLA anthropologist James N. Hill "tested different probabilistic sampling strategies that today form the largest sample taken in California using these methods," claim Fowler Museum experts. According to teaching assistant Dr. Michael Glassow, "Oak Park was one of the closest places to UCLA where you could lead a field class on an archaeological site . . . and we worked there under an agreement with the corporation that owned the site and they welcomed our group." (UCLA.)

NATIVE GRASSLANDS. Much of the Oak Park terrain, which is a mix of grasslands and a riparian oak woodland, has remained the same for thousands of years. "Oak Park is one of the oldest occupied places in our part of California," recalls veteran resident Tom Boles. "There are so many undeveloped and unspoiled areas in our community that are truly beautiful prehistoric landscapes. This makes Oak Park very special." This photograph is from 1970. (Photograph by Richard W. Smith.)

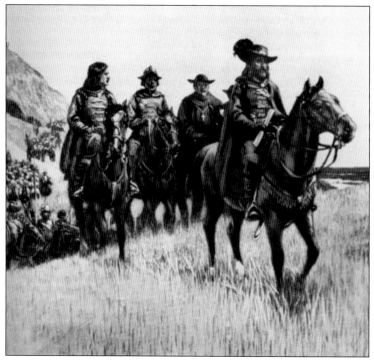

DE ANZA. One of the first European explorers of this area, Juan Bautista de Anza, camped out near Las Virgenes Road in Calabasas. In fact, a Calabasas park is named after his expedition. A hiking trail that skirts the hills above Calabasas is named after him as well. (Los Angeles Public Library.)

MEXICAN ADOBE. Pascual Botiller built this two-story adobe in Santa Barbara in 1843. Today, it houses the Casa Dolores Center for the Study of the Popular Arts of Mexico. According to the late historian Pat Allen, the Botiller family also settled in Ventura County and may have owned an orchard along Oak Park's Medea Creek from the 1850s to the 1870s. (Casa Dolores.)

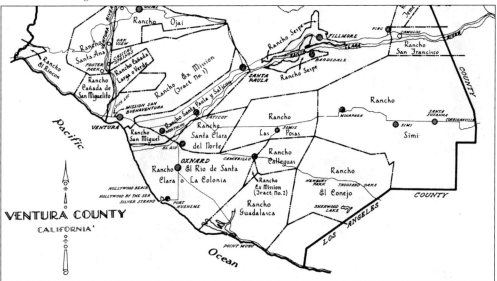

VENTURA COUNTY SPANISH LAND GRANTS MAP. Oak Park is within the Rancho Simi land grant (on the right side of this map) at the southeastern corner of the county. Because the community is immediately adjacent to Rancho El Conejo's eastern boundary (*lindero* in Spanish), it is commonly considered part of the Conejo Valley. But, in fact, much of Oak Park land is technically located in a separate valley, wedged between rolling hills and variously identified as Agoura Valley, Oak Valley, or Las Virgenes Valley. (Ventura County Records.)

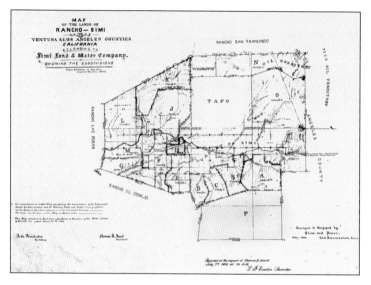

SIMI LAND & WATER COMPANY MAP, 1888. This 1880s map shows small surveying details in its southernmost Tract P (where Oak Park is located today, at the map's bottom), as it was a remote section of Rancho Simi and south of the farms of Simi Valley. This map was commissioned by the owner of the land, state senator Thomas Bard. (Ventura County Records.)

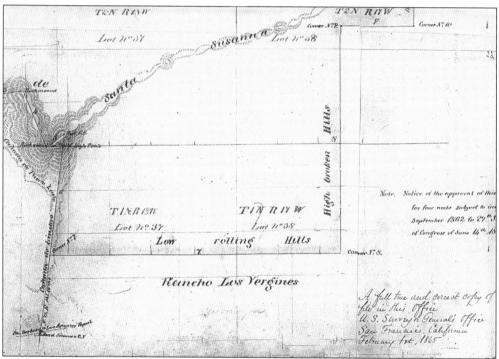

RANCHO SIMI MAP, SHOWING OAK PARK AREA IN 1860S. Oak Park is within the southernmost tip of the Spanish land grant, bounded by Lindero Canyon (here called Cañada de Lindero) on the west, low rolling hills to the south, and high broken hills to the east. This map, prepared by the US Surveyor General of California in 1865, shows Rancho Los Vergines [sic] to the south and identifies Simi Ridge as Sierra de Santa Susanna. "It is very clear from this map that the Spanish/Mexican name for the Simi Hills was the Santa Susanna Mountains," says Mike Kuhn, "And only later, during the Anglo-American period of settlement, was the name changed." (Simi Valley Historical Society.)

WILLIAM RANDOLPH HEARST. In 1925, the newspaper magnate and one of the richest men in the country bought 40,000 acres of ranchland extending from the Conejo Valley to Upper Las Virgenes Canyon, including future Oak Park land. Legend has it that he bought the land looking for oil. He never found it. (Bison Archives.)

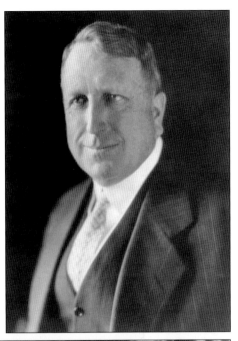

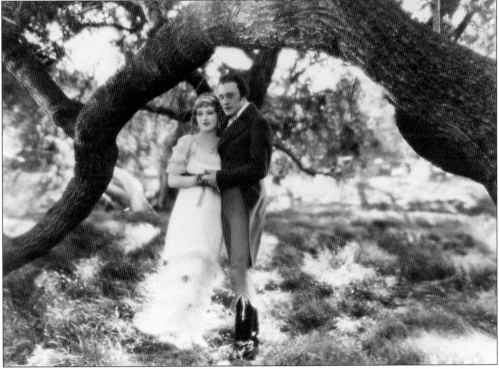

MARION DAVIES AT LAKE SHERWOOD. According to historian Patricia Russell Miller in *Tales of Triunfo*, Hearst only seldom visited his extensive Agoura Ranch holdings. One time, he visited his favorite actress and significant other, Marion Davies (seen here with costar Conrad Nagel), during the filming of her 1927 movie *Quality Street* in Lake Sherwood, some eight miles away from the Oak Park area. (Bison Archives.)

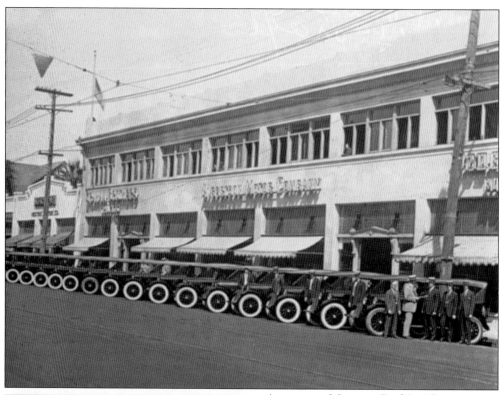

ALBERTSON MOTORS. Fred S. Albertson was the president of the Motor Car Dealers Association in the early 1920s. He bought parcels of Hearst ranch land in 1943. For many years, the area, called the Albertson Ranch, included parts of Westlake Village, Thousand Oaks, and Oak Park. Parts of the ranch were later sold to the Crummer Corporation. (The *Jalopy Journal*.)

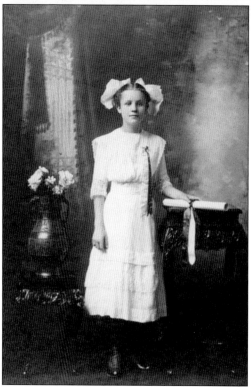

THE COUNTRY GIRL, YOUNG MARIAN JORDAN. The Jordans always had a connection to the land. This photograph of Marian as a prairie girl from the 1910s was taken near the family homestead in Peoria, Illinois. She met her future husband at choir practice when she was 16 and Jim was 17. According to the Jordans' NBC publicists, "The first fresh delight of that boy and girl courtship and the down to earth goodness of small town America are at the very core of the popularity of Fibber McGee and Molly." (Molly Jordan Archives.)

FIBBER'S CLOSET. As Fibber McGee and Molly, Jim and Marian Jordan were among the nation's top radio comedy stars. Future rancher and neighbor Bob Hope was one of their few rivals in the ratings. Their long-running show (1935–1959) reflected the mood of the country, from the Depression through World War II and American suburban dreams of the 1950s. The show's most famous running gag is seen here. Fibber's legendary closet was always crammed full of clutter, and whenever someone accidentally opened that closet door, the contents spilled out in an endless sound effect rumble. (Molly Jordan Archives.)

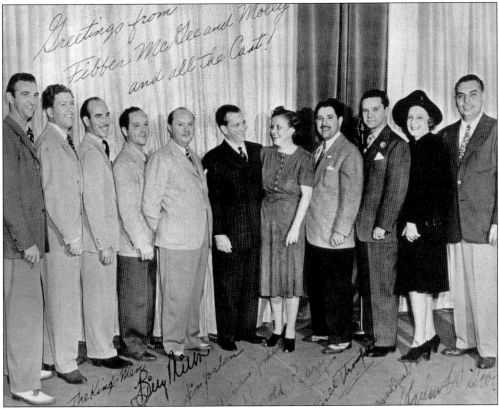

FELLOW RANCHER AND RADIO PERFORMER JON DODSON. Jim and Marian Jordan were joined each week on their show by a large cast of performers, including the King's Men, a popular singing group. The King's Men's mustachioed lead tenor Jon Dodson (third from the left) ended up buying Agoura Hills ranchland nearby the future ranch of his costar friends, the Jordans. Dodson helped revive the old Reyes Adobe, which he owned and lived in. Today, a suburban street called Jon Dodson Drive in Agoura Hills intersects the Reyes Adobe. (Bison Archives.)

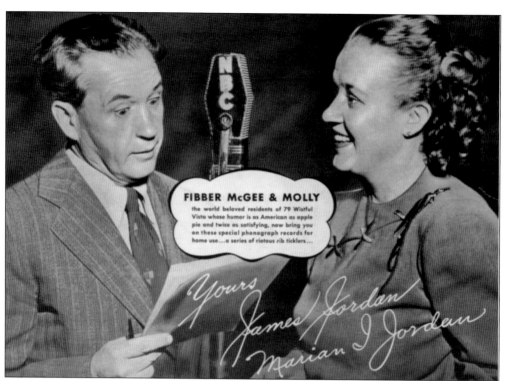

AMERICA'S SUBURBAN ADDRESS: 79 WISTFUL VISTA. The McGees lived in a fictional midwestern housing development with the tongue-in-cheek name Wistful Vista (which means, "The outlook isn't so good," said Molly). The characters won their home, located on a street also known as Wistful Vista, in a real estate raffle. "If you are a typical American, on some Tuesday night you tuned in on an NBC show called 'Fibber McGee and Molly,' " claimed a *Fan* magazine article in February 1946. The story contended that "79 Wistful Vista has become better known to most Americans than any other street address in the world, including 1600 Pennsylvania Avenue." (Molly Jordan Archives.)

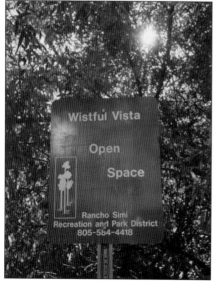

OAK PARK'S TRIBUTE TO THE JORDANS. The Jordans moved to California along with NBC radio operations by the 1940s and bought a home in Encino plus a 4,000-acre ranch near Bakersfield as a retreat. "Jim is reputed to be a first-class cattle rancher," reported *Fan* magazine in 1946, "which makes him prouder than compliments on his radio show." In 1954, the Jordans invested in another getaway, 5,700 acres of ranchland (part of which would eventually be developed as Oak Park). As a humorous homage to Fibber McGee and Molly's suburban community on their radio program, the parks and recreation district dubbed Oak Park's central rolling hills "Wistful Vista Open Space." (Greg Tucker.)

THE JORDANS AT THEIR ENCINO HOME, 1950S. Jim and Marian Jordan loved the great outdoors and spent many hours in their garden at their Encino home. They also enjoyed numerous weekends at their ranch in the Oak Park area. Feed company deliveryman Buck Wicall recalls bringing salt and feed to the Jordans at their ranch. The path to the ranch used to be a washboard dirt road that would "shake your truck apart and knock your teeth out," Wicall recalls, "I was so happy when Jim finally paved it that I was grinning like a possum. Jim used to stand there on the porch waving to me. Jim and Marian were good solid people, old-fashioned and down-home decent to the core." (Molly Jordan Archives.)

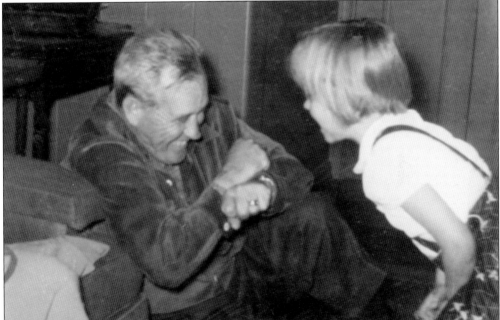

JIM JORDAN AND GRANDDAUGHTER JANICE, 1956. Pictured here is future television comedy writer Janice Jordan playing with her grandfather in Encino, California. Today, Janice recalls her childhood car trips to her grandparents' ranch. "On one trip in their big blue Cadillac, Gramma and Grampa taught us one of their big vaudeville songs, 'Side By Side.' Grampa was an Irish tenor, so imagine my learning this tune while Gramma sang the harmony. I can conjure up the smell of sage, the neighing and mooing of the horses and cows, and bumping up and down around the ranch in a dusty jeep with no doors, their white ranch house and a big red barn with a hayloft to play in!" (Janice Jordan Archives.)

JORDANS' GRANDDAUGHTER MOLLY, 2011. Activist Molly Jordan spoke at an Oak Park History Night event at the Oak Park Library, not far from the former site of her grandparents' ranch home. Jordan fought to preserve Oak Park's nearby open spaces and in particular Palo Comado Canyon, formerly known as the Jordan Ranch. "My grandparents taught me to love nature, open space, and the animals that live on it," she recalls. "I learned a respect for the environment from watching them on the ranch, around their dogs or in my grandmother's case, in her rose garden and among the trees that grew there. They were warm and respectful folks and extended their loving qualities as much to the earth as they did to the people around them." (Photograph by Harvey Kern.)

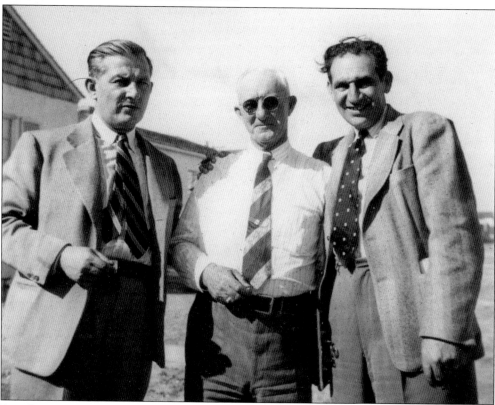

LOU BOYAR AND ASSOCIATES, 1950s. Boyar (right) built homes through his Metropolitan Development Corporation (MDC) throughout Southern California. According to Oak Park resident Barbara De Minico (who previously lived in a Boyar development in Woodland Hills), MDC homes were considered model houses built to last. (Karen E. Kennedy Archives.)

OAK PARK BUILDER LOU BOYAR. Lou was best known for developing the community of Lakewood, California, the first postwar super-suburb in America. Hailing from the humble city streets of Chicago, he may have named "Oak Park" after the Ventura County area's oak trees—along with memories of the comfortable Illinois neighborhood he could only dream about in his youth. (Karen E. Kennedy Archives.)

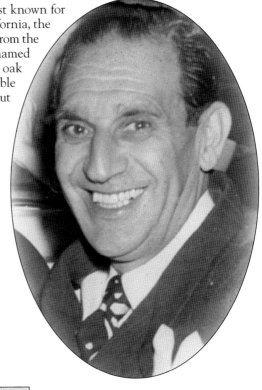

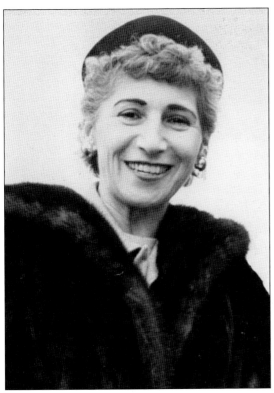

OAK PARK INSPIRATION MAE BOYAR. "Mae saved and borrowed the $700 that Lou needed to begin a construction company when they moved to Los Angeles in 1934," says historian D.J. Waldie, author of *Holy Land*, a memoir of life in Lakewood, California. Mae suffered from a debilitating case of arthritis from the age of 22 "but she never lost her upbeat and generous spirit," according to her granddaughter Karen Kennedy. Mae even helped build a clinic dedicated to the treatment of the disease. Boyar dreamed up many of the conveniences that Oak Park locals take for granted, like the broad esplanades and landscaped medians on Kanan Road that separate residential streets from the main artery. She did not live to see Oak Park to its completion, as she died in 1960. (Karen E. Kennedy Archives.)

LOU AND MAE BOYAR, 1950s. When they were first starting out, Mae lent Lou the initial funds to get into the real estate business. Having spent her childhood on the streets of Chicago, Mae felt strongly about assuring that their developments were family-friendly and wanted to build traffic-free places for kids to play. After her passing, Lou donated land for playgrounds and community green areas to be developed in her name at communities in Oak Park, West Hills, and Lakewood. (Karen E. Kennedy Archives.)

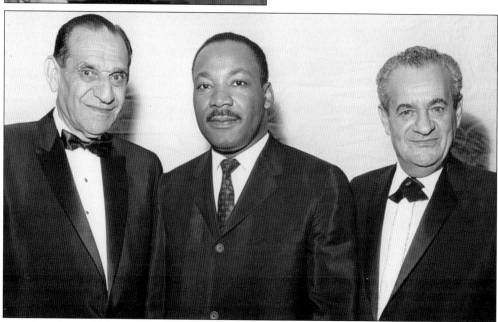

LOU AND MARK BOYAR GREET MARTIN LUTHER KING JR., 1960s. Lou's brother Mark Boyar (right) was president of Metropolitan Development Corporation and helped build the California town of Montebello. Mark was the finance chairman for the L.A.-based 1960 Democratic National Convention, for Los Angeles mayor Tom Bradley and reportedly helped head up JFK's inaugural committee. (Karen E. Kennedy Archives.)

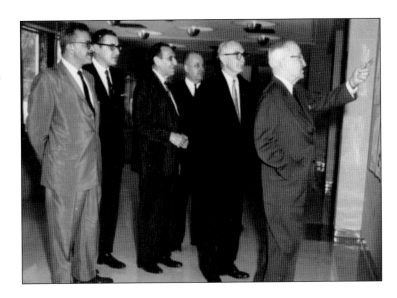

LOU, HARRY S. TRUMAN, AND ADVISORS, 1960S. Lou Boyar (third from left) was an honorary board member of the Truman Institute for Peace, located at Hebrew University in Jerusalem. Here, Lou looks on as former president Truman points to center plans at a press event in Independence, Missouri. (Karen E. Kennedy Archives.)

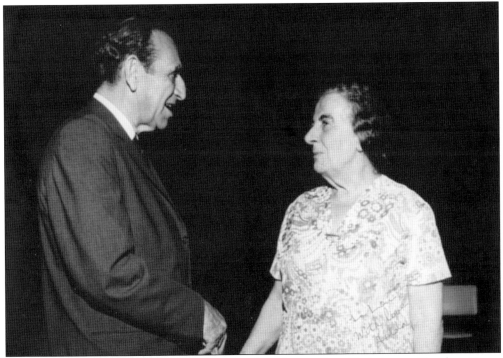

LOU AND GOLDA, 1960S. "Mae and Lou were ardent Zionists," recalls their granddaughter Karen Kennedy. Lou Boyar was involved in the development of the State of Israel and enjoyed a warm and cordial relationship with Israeli prime minister Golda Meir. He was a cofounder of Israel Bonds, the United Jewish Welfare Fund, and American Friends of Hebrew University. In his Oak Park development, where many streets are named after trees, he named one of the streets Sabra Avenue, after the Israeli cactus fruit. Ironically, Hebrew is one of the most frequently spoken second languages in Oak Park today. (Karen E. Kennedy Archives.)

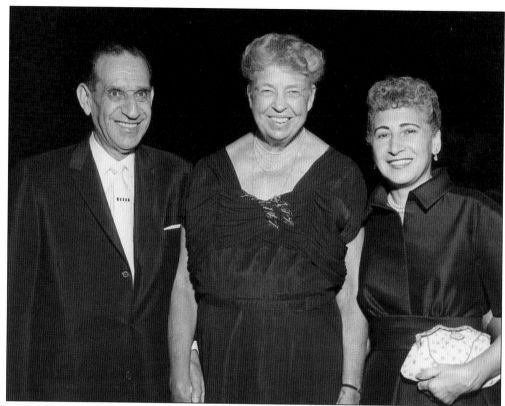

LOU AND MAE BOYAR GREET ELEANOR ROOSEVELT, 1959. The Boyars were among the top fundraisers for the Democratic Party and welcomed many dignitaries into their life. (Karen E. Kennedy Archives.)

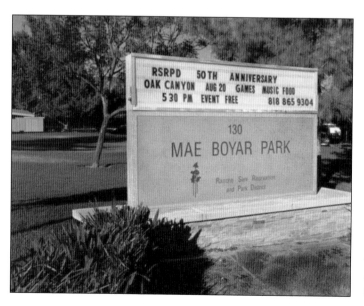

MAE BOYAR PARK TODAY. In 1965, Lou Boyar donated six acres of his property and funds to create this playground and community center in Oak Park in his late wife's name. Mae was known as a cofounder of Pioneer Women and a clinic for arthritis research and treatment that later became part of the future Cedars-Sinai Medical Center. (Brian Rooney.)

Two

Welcome to the Country
The Road to Oak Park

To provide access to the new community of Oak Park, which began selling homes in 1966, Metropolitan Development Corporation extended Kanan Road. It originally connected Highway 101 with the Hillrise tract in the community of Agoura (now Agoura Hills), just north of the 101.

Kanan Road also had four lanes—two in each direction—and extended to the original Oak Park model homes, about two miles north of the 101. For years, this was the only ingress and egress to the community of Oak Park. Land on either side of Kanan Road was used to farm and raise cattle long before housing tracts were developed there.

Kanan Road was named after the pioneering Agoura family that provided the land for the road. In 1985, the family name tragically made headlines when local 60-year-old businesswoman Judy Kanan was murdered while feeding her horses.

In the old days, the Oak Park area was just one part of the vast Agoura Ranch holdings. Before Kanan Road was built, the main highway exits for the area would have been Cornell Road, which headed southwest to Seminole Hot Springs, and Chesebro Road, which offered access to the old Jordan Ranch.

The Agoura area was known as "Picture City" because of the numerous movie ranches and locations nearby, including Paramount Ranch, Fox Ranch (Malibu Creek State Park), King Gillette Ranch, and Agoura Road (a location for the opening of Jane Fonda's *Walk on the Wild Side*). Independent film companies that did not own their own ranches often rented the Hearst Agoura Ranch.

A number of actors lived nearby, including silent screen star Laura La Plante (a street is named after her) and Western actor George Chesebro (who owned a ranch near today's Chesebro Road).

The western end of the ranch that would become Oak Park was appropriately called *lindero* (Spanish for "boundary") and the center of it was called *medea* (Spanish for "middle"). Even today, Medea Creek is considered the middle of the Oak Park development.

The July 1991 edition of *Country & Canyon Times* offered a little more history of the area and the road to Oak Park. "As told to Molly [Jordan] by her father, Jordan Ranch originally was part of a Spanish land grant. William Randolph Hearst bought 40,000 acres and later sold 15,000 acres to the Crummer family of Malibu, who sold approximately 5,700 acres to Jim Jordan Sr. In 1961, Jim Jordan Sr. and his son Jim (Molly's father) sold 1,300–1,700 acres of the total 5,700 acres they owned to Bob Hope."

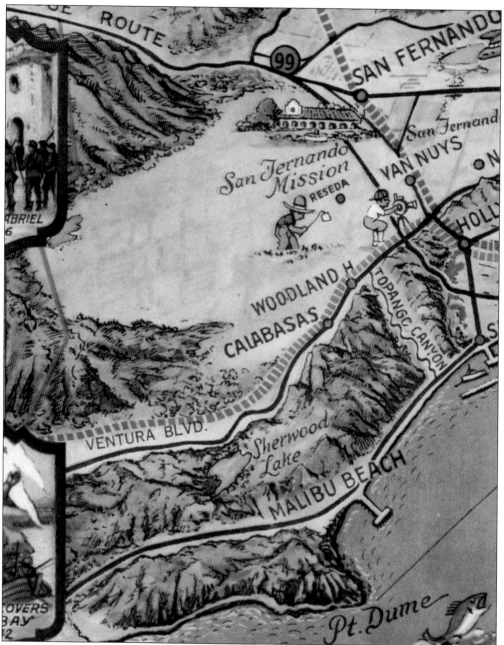

West Valley Map, 1954. Before the freeway opened in the 1960s, the only way to Oak Park was along Ventura Boulevard (see dotted line), which was a scenic road through San Fernando Valley farmland surrounded by the Simi Hills (above the boulevard to the left) and Santa Monica Mountains (below the boulevard). Note the farmer and moviemaker icons, representing the two industries of the valley. (Brian Rooney Archives.)

VENTURA FREEWAY AREA IN THE 1910s. This dusty byway, which was near the site of today's 101 Freeway, was once called Los Angeles and Ventura Road because it was the main artery taking travelers from Los Angeles to Ventura County. This historic photograph was taken near today's Las Virgenes Road and the 101 looking west toward Agoura and Oak Park. (Calabasas Historical Society.)

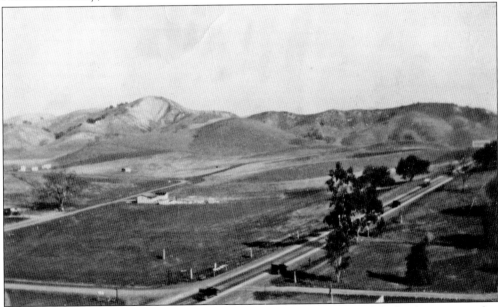

AGOURA, LOOKING EAST TOWARD CALABASAS, 1925. Farms once dotted the landscape near what is the modern-day intersection of the Ventura Freeway and Chesebro Road. Agoura was once known as Independence Acres or Picture City because of all the movies shot in the area's open spaces. (Las Virgenes Historical Society/Agoura Hills Library.)

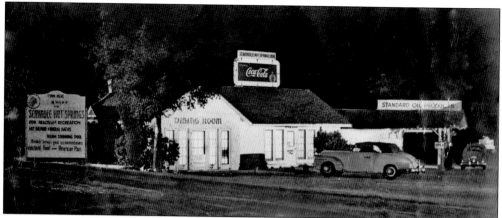

LONELY 1940s ROADHOUSE/FUTURE HOME OF PADRI. One of the few outposts in the lonely Agoura area was this roadhouse/gas station at the corner of Cornell and Agoura Roads, a possible pit stop on the road to today's Oak Park. Although this roadhouse was called the Seminole Hot Springs Inn, it was actually located six miles before the once-popular hot springs resort. This rustic restaurant can be seen briefly in 1946's *The Postman Always Rings Twice* (as identified by longtime local Charlie Lieberman) and in the 1960s sci-fi television series *The Invaders*. It has since been revived as Padri Restaurant and Martini Bar. (Las Virgenes Historical Society/Agoura Hills Library.)

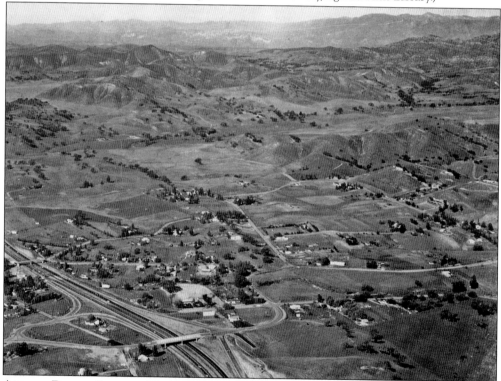

AGOURA RANCH, LOOKING NORTHWEST, EARLY 1960s. Before Oak Park was developed in the 1960s, it was considered part of the Agoura Ranch. The area that became Oak Park can be found at the top right of this photograph, where a row of oak trees lines Medea Creek. The Chesebro Road exit (with an overpass clearly visible at the bottom of this photograph) was the main route to the Oak Park area at the time. (Las Virgenes Historical Society/Agoura Hills Library.)

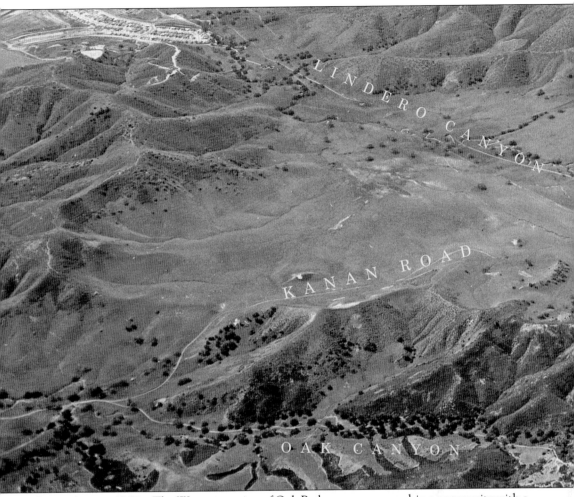

GREEN ACRES, 1960s. The Western section of Oak Park was once a ranching community with a few dirt roads. Developers eventually paved the ranch's main macadam road (the future Kanan) and Lindero Canyon and turned Oak Canyon's Medea Creek into a community park. Today's amenities include a dog park (one can spot the surrounding hills in the bowl above the "K" in "Oak Canyon") and an archery range (located amidst the oaks to the left of the "K" in "Kanan"). (Ed Lawrence.)

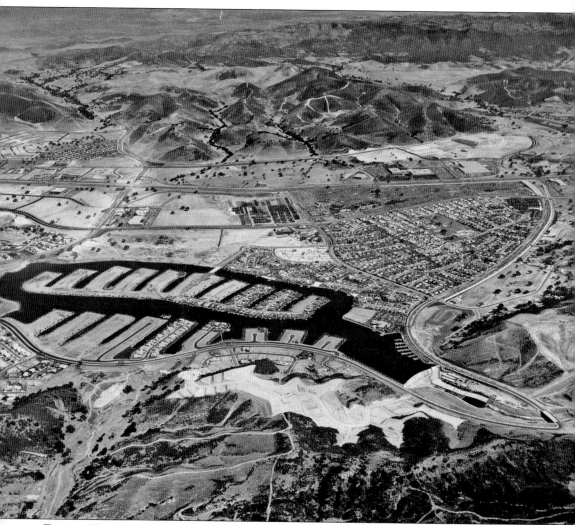

FUTURE HOME OF WESTLAKE VILLAGE, 1960s. This is a photograph of Westlake Village under development, with Westlake Boulevard on the left, above the man-made reservoir and Westlake Village's First Neighborhood and Lindero Canyon Road on the right. The hills of Oak Park are at the top right. (Photograph by Ed Lawrence.)

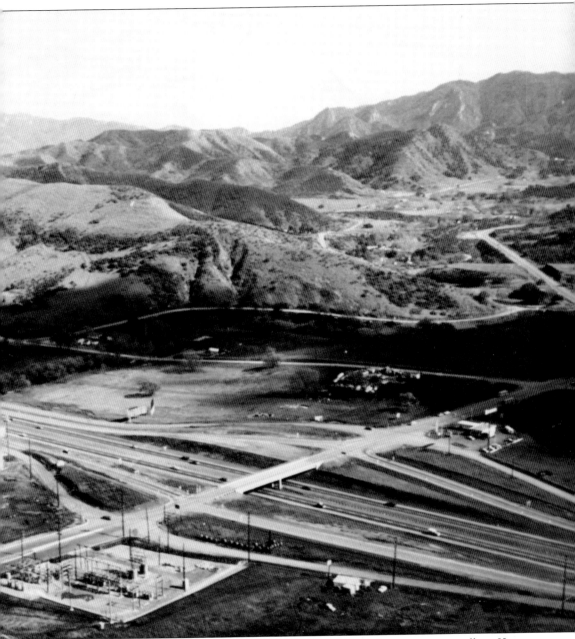

KANAN ROAD: THE GATEWAY TO OAK PARK, 1964. A newly built freeway overpass allows Kanan Road to continue from the Santa Monica Mountains (top of photograph) into the future Oak Park. The first Oak Park families had to head to Woodland Hills for their groceries until Whizin's shopping center was built south of the freeway in the early 1970s. The SCE electrical substation, today hidden by trees, can be seen at the bottom left. (Las Virgenes Historical Society/Agoura Hills Library.)

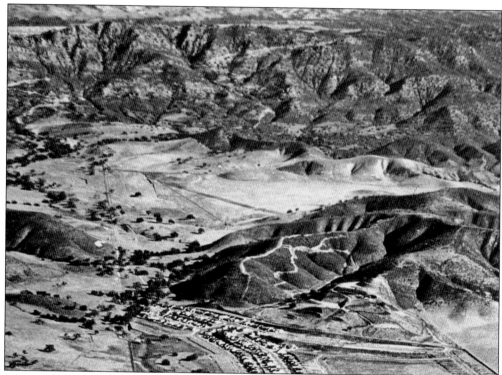

LINDERO CANYON, LATE 1960s. The Lindero portion of the future community of Oak Park can be seen in the lighter valley region in the middle of this photograph. (Photograph by Ed Lawrence.)

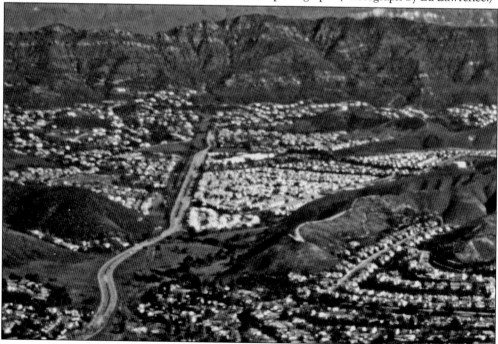

LINDERO CANYON, 1983. Decades later, the Lindero has been developed and populated. North Ranch is to the left of Lindero Canyon Road, while Oak Park is to the right. (Ed Lawrence.)

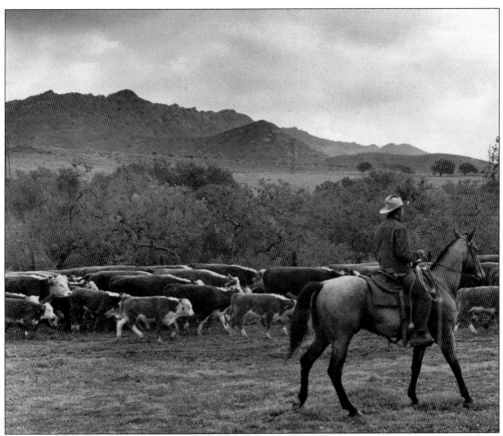

NORTH RANCH CATTLEMAN. With Simi Ridge as a backdrop, a cowboy herds cattle along the oaks. Today, members of the North Ranch Country Club can get this same view from the Oaks Lounge dining room. Oak Park is to the right of the hills. (Photograph by Ed Lawrence.)

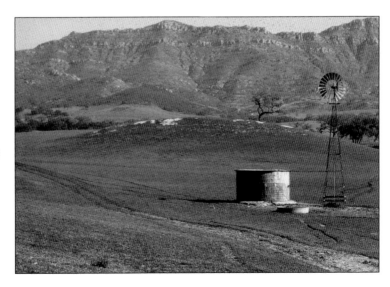

OAK PARK AREA RANCHLAND, 1960s. Water tanks and windmills were common sights on the cattle ranches below Simi Ridge. When the first houses were built in Oak Park, these sights were in one's backyard. (Photograph by Ed Lawrence.)

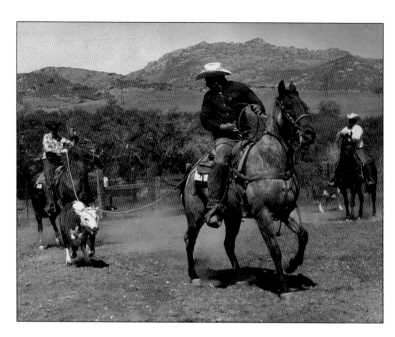

GIT ALONG, LITTLE DOGIE. North Ranch cowboys rope a calf on the Sutton Ranch, not far from today's Sutton Valley in Oak Park. (Photograph by Ed Lawrence.)

KANAN ROAD EXTENSION, 1960s. Even before the houses in Oak Park (middle of photograph background) were finished, Metropolitan Development Corporation paved this extension of Kanan Road to connect the Ventura Freeway with the development. This was the only entrance into Oak Park for many years. The future site of an Agoura Hills shopping center is on the left. (Las Virgenes Historical Society/Agoura Hills Library.)

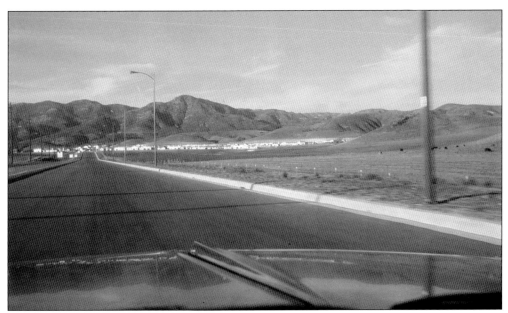

ENTERING OAK PARK, A DRIVER'S-EYE VIEW, 1960s. As visitors drove north on Kanan Road, they would pass by the farmland of the undeveloped Morrison Ranch. The isolated community of Oak Park can be seen in the distance at the base of the hills. (De Minico Family Archives.)

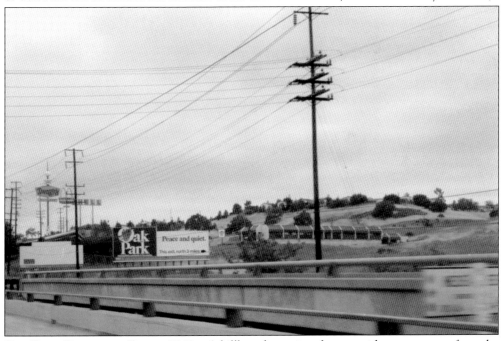

OAK PARK, PEACE AND QUIET, 1960s. A billboard promises future residents an escape from the urban rat race—a promise that is still fulfilled today. The "peace and quiet" message was well placed at this once-cluttered stretch of the Ventura Freeway at the Kanan Road off-ramp. Los Angeles travelers would joke that on the way to Thousand Oaks, one had to first pass Agoura's "Thousand Billboards." Activist Mary Wiesbrock was instrumental in getting the community to create a code limiting the billboard clutter along the freeway. (Russell Paris.)

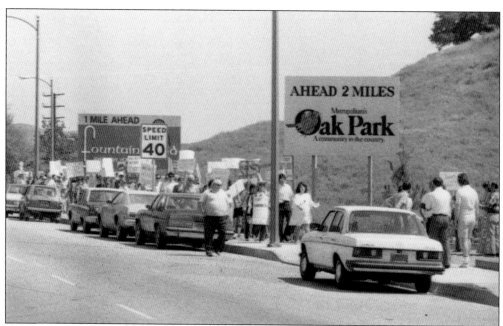

Two Miles Ahead. A sign at the corner of Kanan and Hillrise Roads, just north of the freeway, touted Oak Park as "A Community in the Country." Note the competing real estate sign on the left promoting the burgeoning Agoura community of Fountainwood, only "one mile ahead" and closer to the freeway. Area activists staged a protest in front of the signs to draw attention to the need for safer roads to Oak Park. (Photograph by Bob Pool.)

Almost Home, 1960s. The community was located in such a remote region that this directional sign was needed to reassure visitors and residents that they were not lost. (De Minico Family Archives.)

You Are Here, 1970s. This greeting, located on the Kanan Road median just north of Tamarind Street, welcomed visitors to Oak Park. This was the only entry to the community in those days. (Tom Reyes.)

You Are Here, 1990s. This median sign replaced the older one from the 1970s on the eastern section of Oak Park. It also lets motorists know that they have left Los Angeles behind and are entering Ventura County. (Photograph by Harvey Kern.)

YOU ARE HERE, 1990s (WEST ENTRY). The community can now be entered from Lindero Canyon Road on the west side of Oak Park, where this rustic sign appears at the county line. (Photograph by David E. Ross.)

FROM THE MOUNTAINS TO THE SEA. One of the many advantages of living in Oak Park is that Pacific Ocean is roughly 15 miles away via Kanan Road, with cooling breezes wafting through the canyon. This scenic route to the beach passes by such points of interest as the Malibu Wine Country, the house from the series *The Bachelor*, Troutdale, Calamigos Ranch, and Newton Canyon Falls. (Harry Medved.)

Three

FROM THE GROUND UP
EARLY DEVELOPMENT

Metropolitan Development Corporation (MDC) bought Jim and Marian Jordan's ranch in the 1960s to create a suburban community. Following the prior efforts of Louis Boyar (the head of MDC) in developing the city of Lakewood, California, new ranch homes were built on the property.

To serve an expected population of 26,000, Kanan Road was developed as a divided highway with two lanes in each direction connecting the Ventura Freeway (US 101) with the community and running through undeveloped land in Los Angeles County on its way to Oak Park. The Kanan right-of-way included a water supply line to serve future development. Sewer mains had also been laid with capacity sufficient for the completion of the expected expansion.

After the initial development was completed, new MDC leadership initiated a planning effort leading to the Oak Park Community Development Plan, a planning effort spanning 1970 to 1972. The board of supervisors of Ventura County rejected the plan, along with any further urban or suburban development outside of incorporated cities. "Ventura County officials were leery of the huge Oak Park proposal because of the massiveness of the project," Bob Pool wrote in the *News Chronicle*, "and its remote distance from the Ventura County seat, where the planning process and building inspection work takes place."

This resulted in a building moratorium in unincorporated Oak Park in early 1973. MDC filed a lawsuit challenging the moratorium, which was finally settled in 1974. The settlement included approval of the Oak Park Community Development Plan (and its theme of environmental suitability) and provided that MDC could complete the development of Oak Park but only after an environmental impact report was prepared and approved by the board of supervisors. That report and the resulting revisions to the community's master plan scaled back the expected population to about 16,000. In addition, MDC was required to donate—not sell—the designated sites to the local school, park, and county agencies. Today, the completed development is home to 14,266 residents, according to the 2010 census.

Builders Go West in San

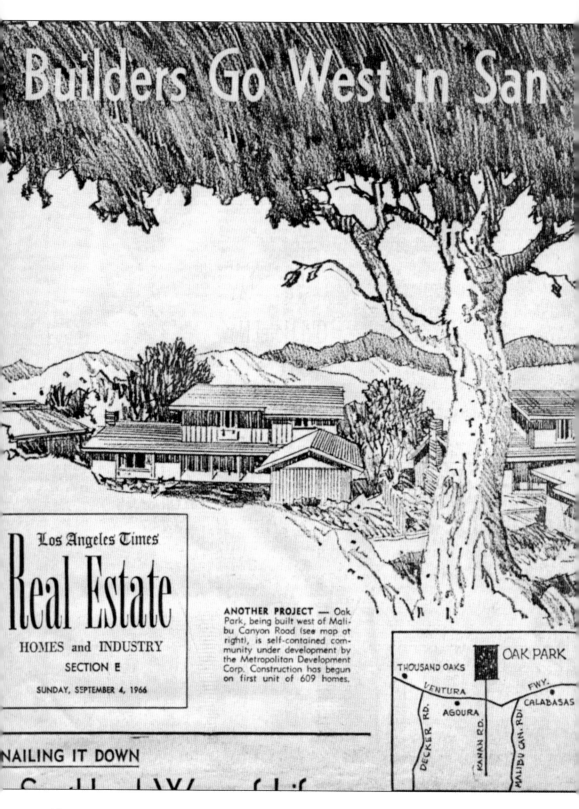

Los Angeles Times
Real Estate
HOMES and INDUSTRY
SECTION E
SUNDAY, SEPTEMBER 4, 1966

ANOTHER PROJECT — Oak Park, being built west of Malibu Canyon Road (see map at right), is self-contained community under development by the Metropolitan Development Corp. Construction has begun on first unit of 609 homes.

NAILING IT DOWN

OAK PARK BIRTH ANNOUNCEMENT. This September 6, 1966, story in the *Los Angeles Times* announces the construction of "the first unit of 609 homes in a self-contained community, west of Malibu Canyon Road." The assessor's map for Oak Park's first tract was drawn on March 30, 1966, and the first model home was located at 30 Kanan Road. (Spencer Resnick Archives.)

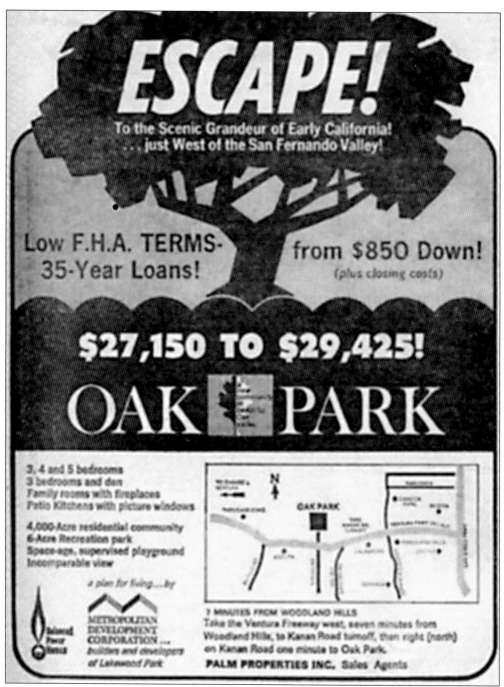

READ IT AND WEEP. In 1968, the dollar went a little farther in Oak Park, with home prices starting in the $20,000 range. This advertisement, promoting the community's "scenic grandeur" reminiscent of "early California" appeared in the *Valley News and Green Sheet*, now known as the *Daily News*. (Harvey Kern Collection.)

FIRST OAK PARK MAP, 1966. A local area map shows the remote little development under way with only eight short streets just outside the Los Angeles County line. Tupelo Street was eventually extended into the hills and renamed Sunnycrest Drive. (De Minico Family Archives.)

A COMMUNITY IN THE COUNTRY. After the first 600 units for Oak Park were sold, MDC built a new phase of homes called Countryview, located east of Kanan Road. In this real estate brochure, Flat Top Hill (also known as Camelback Peak) is featured inside the tree outline on the right. (Oak Park Unified School District [OPUSD].)

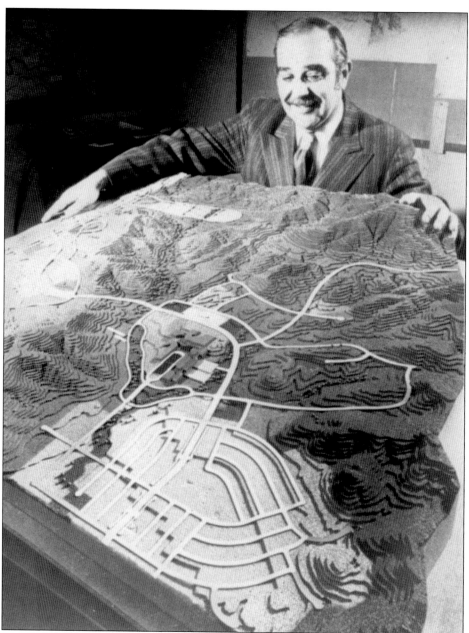

A MODEL COMMUNITY, 1972. A new wave of Oak Park development was designed by Daniel, Mann, Johnson & Mendenhall (DMJM), one of the nation's largest combined architecture and engineering firms. Here DMJM local branch manager Gerald Broms proudly displays the future development of Oak Park, nestled in—but not scarring—the rolling Simi Hills and based on a plan by Richard Warren Smith. "The existing homes were at the bottom of the model," recalls reporter Bob Pool, "and it was pitched as a precedent-setting concept for future communities." According to Smith, the Olmstead design for Palos Verdes, California—and its relationship between the roads and the natural environment—was his inspiration for Oak Park. This photograph was taken in 1975. (Photograph by Bob Pool, courtesy of News Chronicle Collection/Thousand Oaks Library.)

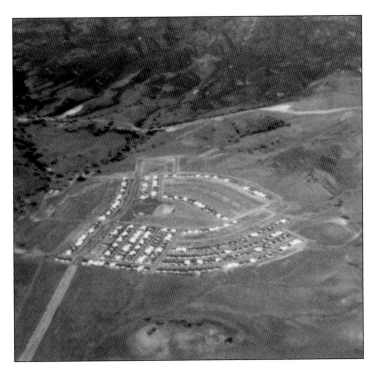

A COMMUNITY IN THE WORKS, 1960s. This aerial shot shows the first roads of what some refer to as "Old Oak Park," the early development east of Kanan Road. The small square at the top of the development was a dirt lot where many kids played; it later became the first commercial center in the neighborhood. Oak Park Dentistry for Children occupies the spot today. Mae Boyar Park can be seen in the middle of the photograph, just south of the square. Medea Creek's Y-like fork is on the left. (De Minico Family Archives.)

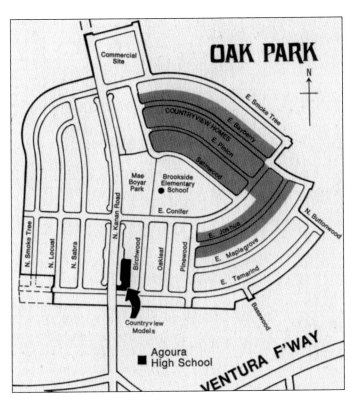

A LITTLE LESS LONELY. This map shows the expansion of Oak Park, with the Countryview homes shaded on the map. It matches up with the aerial photograph above. "I always had sympathy for those early pioneers of Oak Park," says longtime reporter and observer Bob Pool. "They were completely isolated up there, as Agoura Hills hadn't been built yet, so there were no nearby markets or stores. The only way into this Ventura County neighborhood was through Los Angeles County, past neighborhoods whose residents sometimes seemed to look down on those in Oak Park." (OPUSD.)

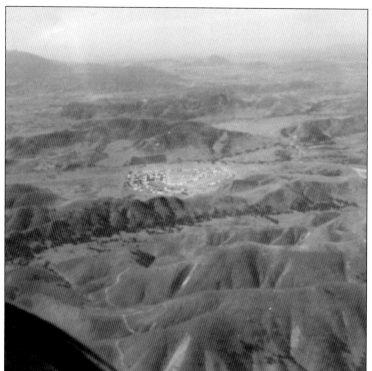

VIEW FROM ABOVE, 1960s. This aerial view emphasizes the isolation of early Oak Park homeowners, surrounded by the rolling hills near Wistful Vista (near the top of photograph) and Palo Comado Canyon, the tree-lined creek across the middle of the photograph. (De Minico Family Archives.)

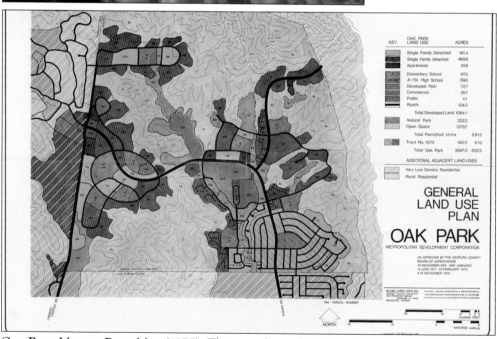

OAK PARK MASTER PLAN MAP (1975). This map shows the results of extensive environmental planning—reportedly California's first for a developer-planned community—conducted for Oak Park and approved by county supervisors. After this map was distributed, adjustments were made in housing types, locations of commercial, park, and school sites, and secondary roads after further environmental reviews. (Ronald Stark Collection.)

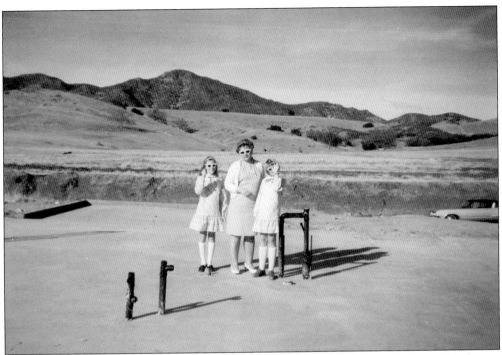

OAK PARK PIONEERS, 1960s. The Dietel family anticipates their future home on Smoketree Avenue east of Kanan Road. Note the utility pipes sticking out of the foundation and the sports car on the far right. The peak at the top of the photograph is commonly misidentified as Simi Peak, when in fact it is unnamed. Because the peak rises near the end of Deerhill Road, some call it Deerhill Peak. (Urusla Dietel Photograph.)

THE FUTURE LIES AHEAD, 1975. Kanan Road dead-ended after Smoketree Avenue, terminating at a gate near Tupelo Street (today's Sunnycrest Drive). Kanan would not extend farther until the high school was built around 1980. (Richard W. Smith.)

SHEEP MAY SAFELY GRAZE, 1960s. Oak Park pioneers reported a common sight on the hills above Smoketree and Buttonwood Avenues. Basque sheepherders managed their flocks in the midst of burgeoning suburbia. (Ursula Dietel Photograph.)

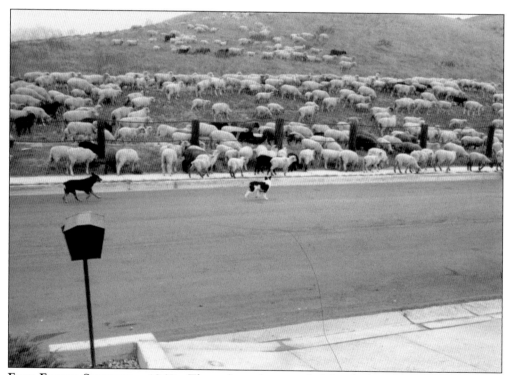

FOUR-FOOTED SHEPHERDS, 1960s. These sheep dogs guarded the flocks and made certain they did not stray into Smoketree Avenue traffic. "We used to watch this elderly Basque sheepherder tending the flocks as well as shearing the sheep," recalls Barbara De Minico, "and one time he gave my son Dan a small lamb, which he meant for us to cook for dinner. At our urging, my son reluctantly took the lamb back to the shepherd." (Alyce Nine Photograph.)

NEW HOMES V. SHEEP. Houses start to sprout up in the open space where the sheep used to have the grazing rights. Today, this area is known as Sunrise Meadows Open Space on Smoketree Avenue, east of Kanan Road. "White owls used to sit on these fence posts at night," recalls veteran resident Ron Stark. (Alyce Nine Photograph.)

WILD IN THE STREETS. The sheep were not the only animals to surprise residents on Smoketree Avenue. In 2006, a black bear was spotted on this street. "I thought I had just seen the darnedest-looking big dog ever," says Smoketree resident Lynn Nine, "I nearly jumped through the ceiling when I realized it was a bear ambling down the street in front of my mailbox." (Alyce Nine Photograph.)

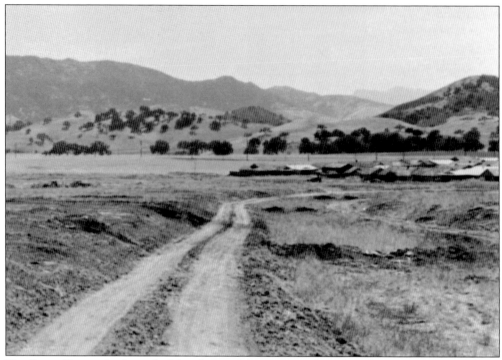

THE ROAD HOME. At the end of this dirt road, houses in early Oak Park are nearing completion in the late 1960s. Real estate brochures promoted the area as "your private retreat from noise and the crowds of the city . . . Green hills, lush valleys, blue skies that are not hidden by smog." (De Minico Family Archives.)

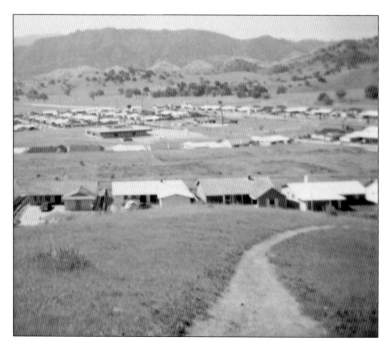

HOMES ON THE RANGE. This view of future suburbia was shot from Smoketree Avenue, east of Kanan Road, looking south towards Agoura's Ladyface Mountain. Much of the open space in this photograph has been preserved by careful planning. (Ursula Dietel Photograph.)

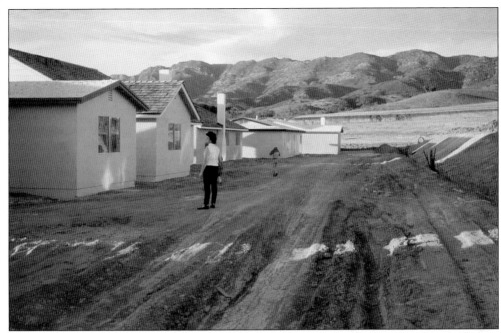

UNFINISHED BUSINESS, LATE 1960s. Oak Park pioneer Barbara De Minico surveys the houses nearing completion and the undeveloped land that will become her backyard. "Houses didn't come with landscaped backyards or front yards in those early days," says De Minico, "And neighbors had to negotiate over the fencing and block wall sizes." (De Minico Family Archives.)

ECOFRIENDLY TRAVEL. The streets of Oak Park in the late 1960s were so traffic-free that equestrians and motorists could peacefully share the road. This photograph shows a horsewoman from Old Agoura giving equestrian lessons to a young Oak Park girl on Smoketree Avenue. (Lynn Nine Photograph.)

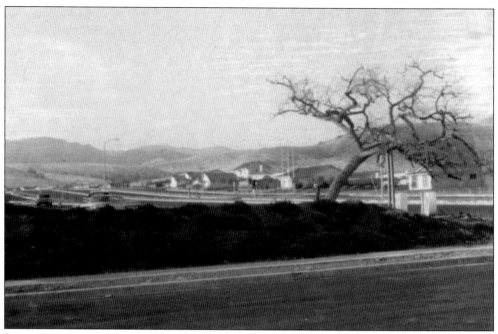

LONE AMBASSADOR. At the entrance to Oak Park, an old oak tree stood guard over four-foot-high block letters (right) spelling out the community name. This photograph was taken at Tamarind Street, west of Kanan Road, looking northeast at some of the community's model homes. (Tom Reyes.)

COW GREEN WAS MY VALLEY. Residents who lived on Tamarind, the southernmost street in the community and the dividing line between Ventura and Los Angeles Counties, had this backyard view of Agoura's Morrison Ranch before development. "It was very quiet here with no shopping within miles, big tarantulas all around," recalls resident Ron Stark, "No lawns and lots of dirt. Not even an asphalt road to your house." (Tom Reyes.)

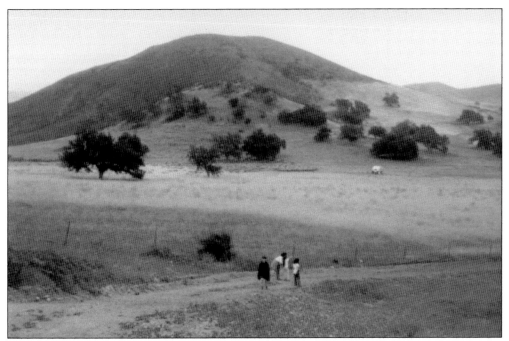

COUNTRY STROLL. Early resident Barbara De Minico and her children enjoy the wild landscape a short walk from their new home. One of the many joys of life in Oak Park is that so many of these oak trees, like the ones pictured here, were spared during development. (De Minico Family Archives.)

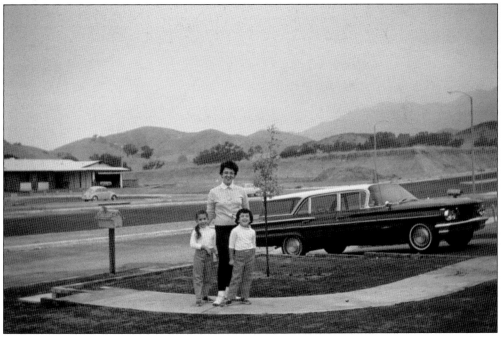

A CAR IN THE DRIVEWAY, A TREE IN THE YARD. Barbara De Minico realizes the American dream as one of the first homeowners in Oak Park. Her 1967 home was located along Kanan Road, just south of Smoketree Avenue. (De Minico Family Archives.)

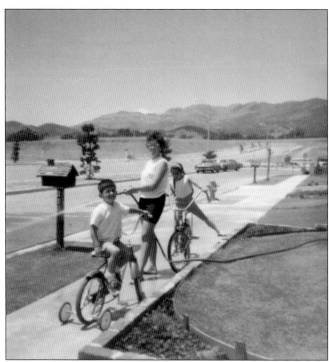

KANAN CUL-DE-SAC. The first model homes built by the Boyars along Kanan Road featured "pocket streets" which enabled children to play safely in front of their homes. Boyar descendant Karen E. Kennedy claims that this Oak Park perk was the brainchild of her safety-conscious grandmother Mae Boyar, who previously advocated this innovation for the streets of Lakewood, California. (De Minico Family Archives.)

KIDS AT PLAY. Barbara De Minico and her children check out the western parts of the community slated for development. "You never had to cross streets to get to the great outdoors," recalled the longtime resident. Her son Dan De Minico (right) recalls that prospective home buyers were treated to free band concerts at Mae Boyar Park and "scenic tract tours via a stagecoach drawn by four horses." (De Minico Family Archives.)

THE GREAT WIDE OPEN, 1970s. For many years, Smoketree Avenue was the northern border of Oak Park. Kanan Road runs through the middle of this photograph, intersecting with Smoketree on the left. The Conifer water tank is near the top of the hill on the right. The trailers on the right were reportedly used by agents of MDC, who advertised the burgeoning suburb with the tagline, "You'll enjoy Oak Park, it's 'Familyland!'" (Richard W. Smith.)

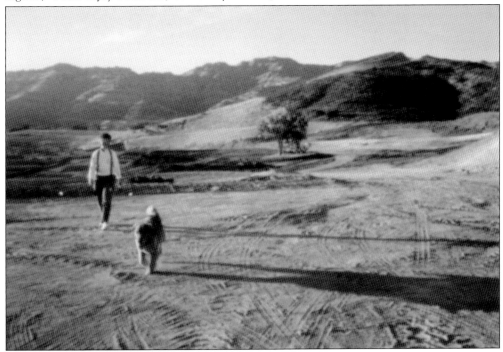

THE WILD WEST END. Future school board president Pat Manning takes a walk with her dog on the western edge of Oak Park, originally known as Sutton Valley. (OPUSD.)

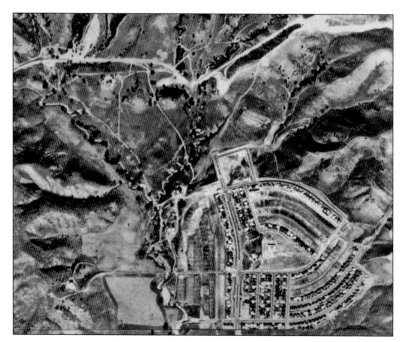

THE BIG PICTURE, 1968. This aerial shot of the original Oak Park tract shows a partially completed development with areas not yet built up with homes. At the left, one can see the two branches of Medea Creek forming a Y near today's Oak Hills Drive and Medea Creek Lane. (Richard W. Smith Collection.)

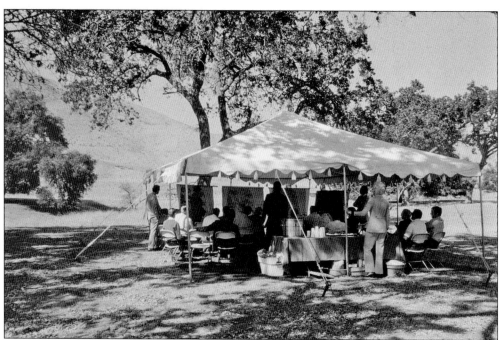

WORKING WITH AND PRESERVING NATURE, 1972. Rudy Schaefer and Henry Hart, MDC leaders in the early 1970s, and DMJM's Gerald Broms and Richard W. Smith present their plan to the Ventura County Planning Commission under a canopy by Medea Creek. Smith's new concept of "environmental suitability" proposed that each parcel should be suitable to its site in terms of slope, view, privacy, and the preservation of natural topography. The plan was approved by the county in 1974. (Richard W. Smith Collection.)

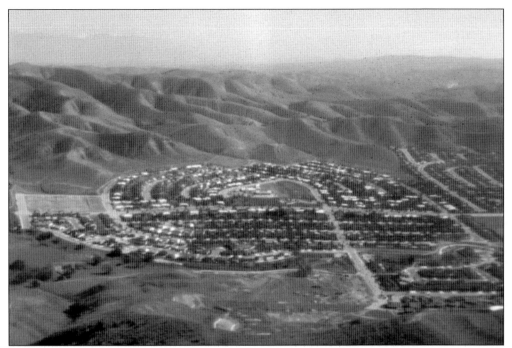

THE BIG GREEN. Once hikers leave Oak Park environs, they are surrounded by thousands of acres of open space, with three canyons completely untouched by development (Palo Comado, Cheeseboro, Upper Las Virgenes) and within walking distance. (De Minico Family Archives.)

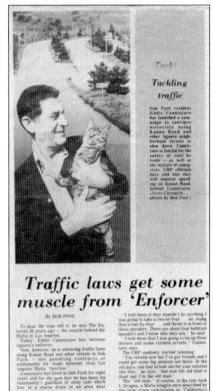

A HIT MAN OR CAT MAN? 1970s. Oak Park resident Eddie Cannizzaro reportedly told neighbors that he was the triggerman who killed gangster Bugsy Siegel in the 1940s. Known to locals as "the Cat Man," the aging Cannizzaro rescued 14 stray cats and waged a campaign against speeders on Kanan Road to protect his pets. (Bob Pool Photograph.)

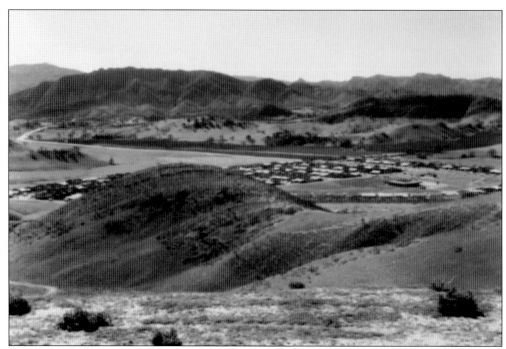

SOUTHEASTERN OAK PARK, 1970. A view from the hills above Maplegrove Street shows the burgeoning development, including Brookside Elementary School and Mae Boyar Park on the right. (Photograph by Harvey Kern.)

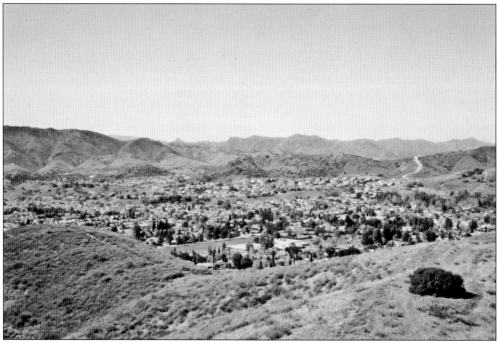

SOUTHEASTERN OAK PARK AND BEYOND, 1999. Nearly 30 years later, the same viewpoint shows the further development of Oak Park, with new homes built in Agoura Hills on the left. (Photograph by Wick Irwin.)

Four

School Days
The Birth of a District

When Oak Park welcomed its first families, there were no schools in the neighborhood. As school activist Pat Manning recalls, "the kids were shuffled all over the place, from Newbury Park to Thousand Oaks." Eventually, Brookside Elementary was built and junior and senior high school students were bused to Simi Valley, a result of local jurisdiction boundaries following the property lines of the old Spanish land grants. Parents stuck it out because of rumors of a planned thoroughfare through the mountains that would directly connect Oak Park with Simi Valley. That road never materialized.

Reporters described Oak Park as "an orphan community" because of its continual turn-downs from closer schools. Three requests to join the Las Virgenes Unified School District (which included Agoura, Calabasas, Westlake Village, and adjacent areas) were denied in the 1970s. Oak Park residents were able to hold their own election on May 31, 1977, in a drive to form their own Oak Park Unified School District (OPUSD) by seceding from the Simi Valley Unified School District. Seventy-three percent of the voters went to the polls, with 93 percent of them approving the new school district.

Over the years, construction was completed on Oak Hills and Red Oak Elementary Schools, Medea Creek Middle School, Oak Park High School, district offices and support services, and Oak View High School. These are award-winning schools, with spirited faculty, students, and parents. *Newsweek* magazine listed the Oak Park High School as one of "The Top 100 in the Nation" in 2003. All of the schools have been named California Distinguished Schools because of the quality of their academic programs, and Oak Hills, Brookside, Medea Creek, and Oak Park High School have all been named National Blue Ribbon Schools by the federal government. The schools rank in the top one percent in student achievement in all of California, and student performance levels are the highest in the county. While many districts struggle to get their students to pass the state high school exit exams, 99 percent of Oak Park 10th-graders consistently pass it on the first try.

A full history of the district's beginnings, *Miracles Happen in Oak Park* by Pat Manning and Marilyn Winters, is available at the Oak Park Library. Today, Manning says, "I am so proud of our school district, seeing the students reaping the rewards of the hard work of so many dedicated parents, teachers, administrative staff, and volunteers over the years."

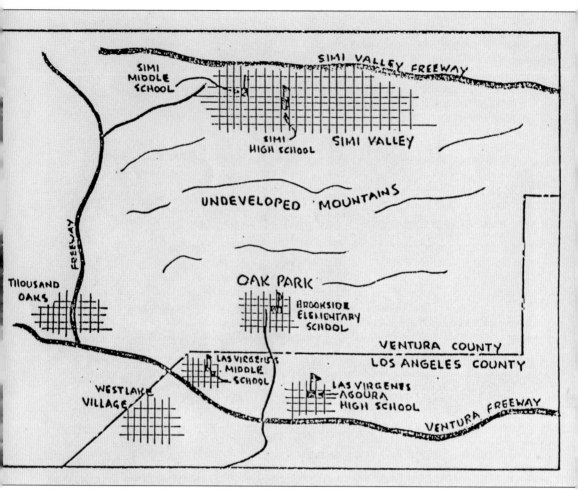

COUNTY LINE BLUES. Ventura County's Oak Park junior and senior high school students were not allowed to attend Los Angeles County's Agoura schools, even though they were just down the street. Therefore, they were forced to take a 46-mile round-trip bus ride each day to the nearest Ventura County schools that would accept them, which were in Simi Valley. Parents would have to drive them separately to games, plays, dances, and special events. This map illustrated the logistics of the dilemma, which community leaders hoped to fix. "The Oak Park area is separated from the rest of the Simi Valley Unified School District by a range of hills that create a natural barrier," school committee leader Pat Manning wrote at the time. "We are a unique, capable, problem-solving community. A unified school district in Oak Park would result in true local control because the school board would be responsible to the residents of our own community." Note that Sinaloa Junior High School (now Sinaloa Middle School) and Royal High School are identified as "Simi Middle School" and "Simi High School," respectively, on this map. (OPUSD.)

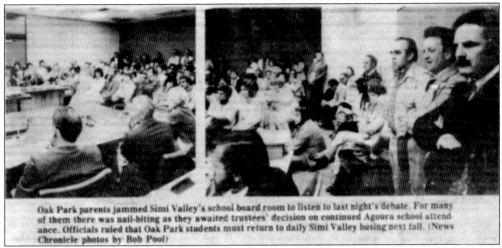

BACK ON THE BUS (FOR NOW). As Bob Pool reported in the *News Chronicle* in 1976, "Oak Park parents jammed Simi Valley's school board [meeting] for the trustees' decision on continued Agoura school attendance. Officials ruled that Oak Park students must return to daily Simi Valley busing." This ruling was one of several disappointments that led to the creation of the community's own school district. (Photograph by Bob Pool/*News Chronicle*.)

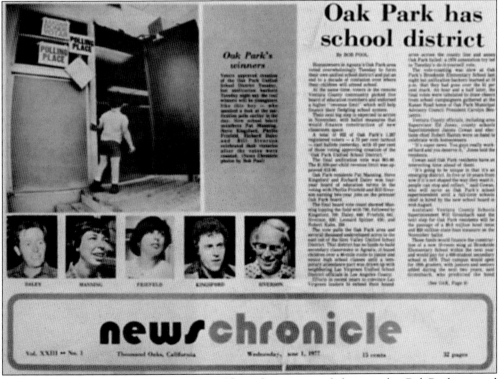

A CHILD PEEKING INTO THE FUTURE. *News Chronicle* reporter and photographer Bob Pool captured this image of a young resident at a polling place, curious about the outcome of the school district election on a day would go down in Oak Park history on May 31, 1977. "We were continually disappointed," says resident Barbara DeMinico, "and shunned like a misbegotten stepchild, so we had to create our own future." (Bob Pool Photograph.)

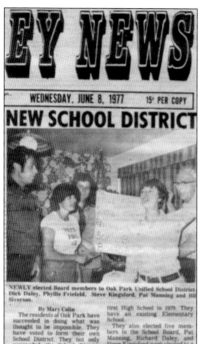

ELECTION VICTORY. Oak Park homeowners voted overwhelmingly—93 percent in favor—to create their own school district. The new board members celebrating here are, from left to right, Dick Daley, Phyllis Friefeld, Steve Kingsford, Pat Manning, and Bill Siverson. (Valley News Photograph.)

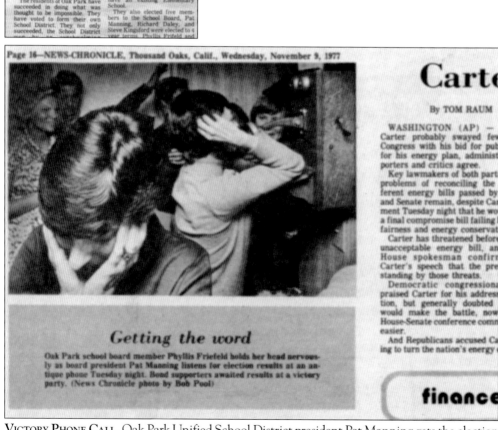

VICTORY PHONE CALL. Oak Park Unified School District president Pat Manning gets the election results, while board member Phyllis Friefeld holds her head in joyous disbelief. (Photograph by Bob Pool/*News Chronicle*.)

READING, WRITING, REDISTRICTING. Newly elected school board members celebrate their victories. Shortly after the heavenly news about the new school district and the new school measures, a new slogan was adopted for the neighborhood: "Miracles Happen in Oak Park." (Photograph by Bob Pool.)

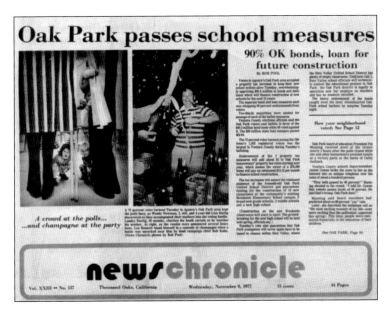

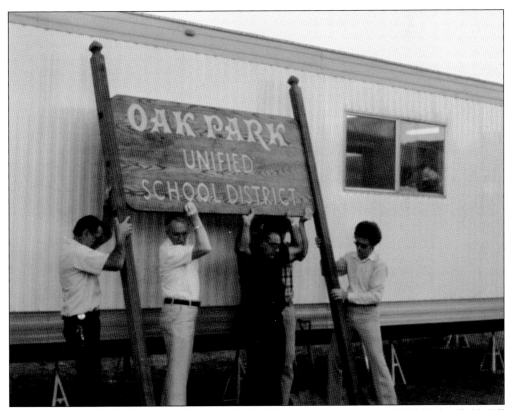

SIGN OF THE TIMES. Early Oak Park Unified School District board members Dick Daley (left), Bill Siverson (second from left), and Steve Kingsford (right) receive help from community volunteer Jack Monico (middle, in front of an unidentified individual) as they pitch in at the construction of the first school district office. (OPUSD.)

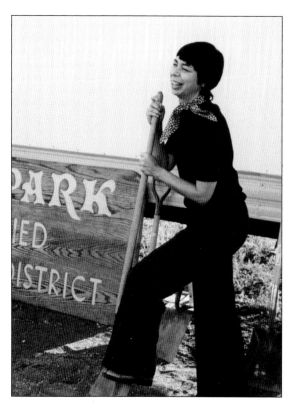

BREAKING NEW GROUND. The "Mother of the School District" Pat Manning proudly grabs a shovel at the ground-breaking of the school district's temporary headquarters. The office was simple—a trailer parked on the grounds of Brookside Elementary School. "We never gave up during our ten-year struggle," recalls Manning. "Our team always found the time, energy and determination to continue working towards our goal." (OPUSD.)

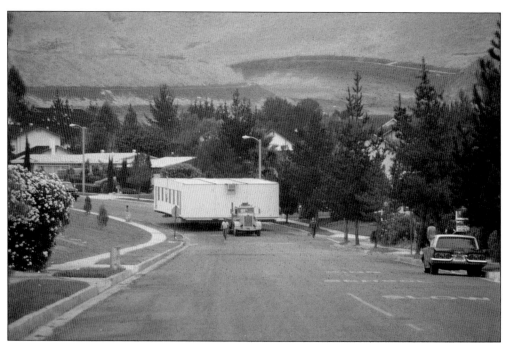

HERE COMES THE MIDDLE SCHOOL. A portable classroom for Medea Creek Middle School makes its way west on Conifer Avenue to its temporary home. (OPUSD.)

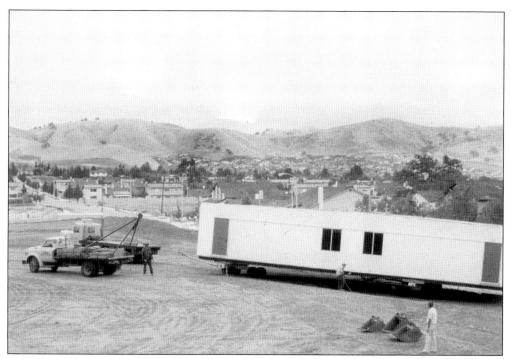

TEMPORARY MIDDLE SCHOOL HOME, 1978. Relocatable classrooms were moved onto a terrace above the future Oak Park Unified School District administrative offices to create a temporary home for Medea Creek Middle School. (OPUSD.)

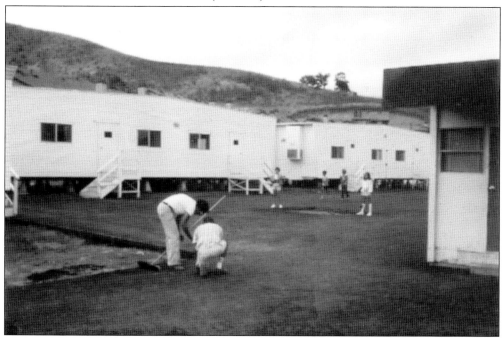

MOBILE SCHOOL, C. 1978. The site at Conifer Street and Medea Creek Lane housed temporary structures for both Medea Creek Middle School and Oak Park High School. After the Oak Park High campus was built, this site ended up as a soccer field. (OPUSD.)

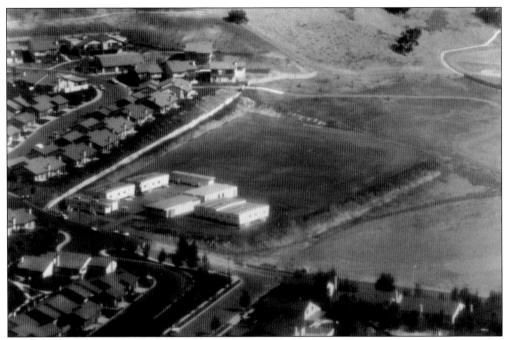

MIDDLE SCHOOL TRAILERS, LATE 1970s. These relocatable trailers for the temporary middle school were placed on a terrace overlooking the area of Conifer Avenue, Conifer Circle, and Sunny Vista Avenue. (OPUSD.)

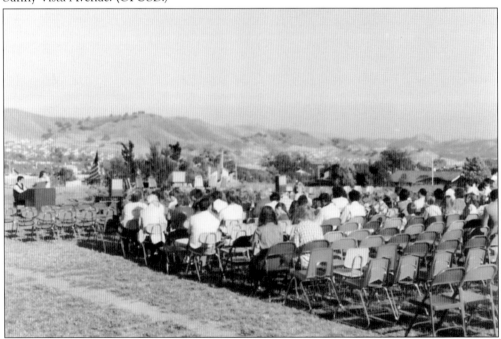

THE FIRST MIDDLE SCHOOL CULMINATION, JUNE 1980. The completion of middle school studies is called a culmination in Oak Park, while the word "graduation" is reserved for the more significant completion of high school. In this photograph, residents gather for the first culmination, while empty seats are saved for the middle school students ready to step up to high school. (OPUSD.)

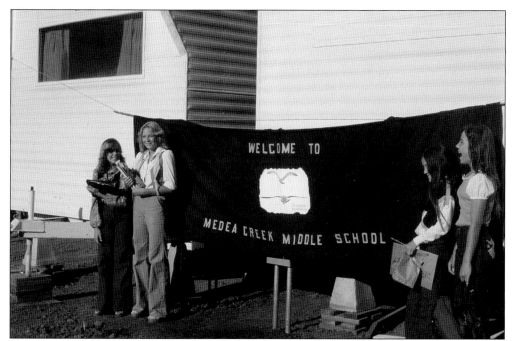

A LOCAL SCHOOL OPENS FOR BUSINESS, 1978. For the first time, Oak Park middle school students did not have to travel into Simi Valley or Calabasas for school. In 1981, classes moved to the current campus of Oak Park High School. (OPUSD.)

MEDEA CREEK MIDDLE SCHOOL, 2011. Home of the Panthers, Medea Creek Middle School finally got a permanent campus in 1992. Like other schools in Oak Park, it is a California Distinguished School and a National Blue Ribbon School. (Photograph by David E. Ross.)

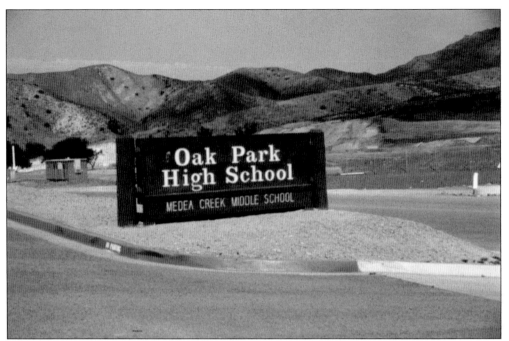

Two Schools on One Campus. For approximately 10 years, Oak Park High School and Medea Creek Middle School shared facilities along Kanan Road. A separate campus for the middle school was built in the early 1990s. (OPUSD.)

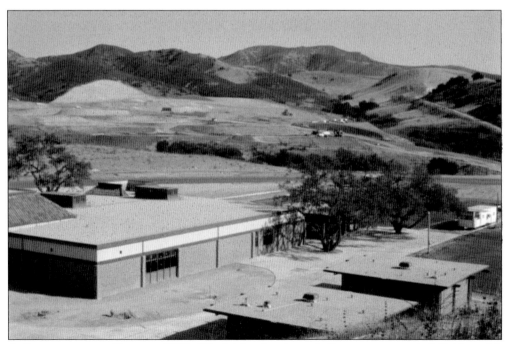

A School with a View, c. 1980. The high school was built amongst scenic hillsides with 360-degree views. This shot shows the school near the completion of construction, with the original Oak Park Library (the main structure on the left). (OPUSD.)

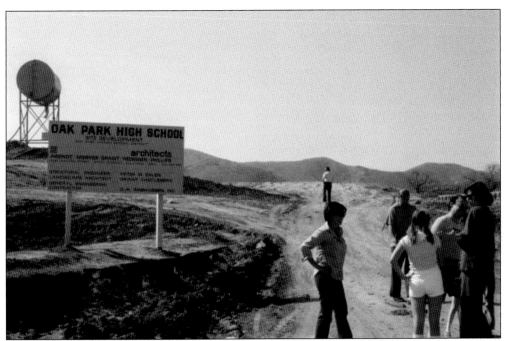

THE FUTURE HIGH SCHOOL GROUNDS, C. 1980. Oak Park Unified School District board members (including Phyllis Friefeld and coauthor David E. Ross) gather at the high school construction site. The tour was conducted by grading contractor Dean Rasmussen. (OPUSD.)

A BANNER YEAR, 1981. The high school dedication was indeed a major and very welcome event in the community. A large gathering of Oak Park residents and their elected officials from Ventura County and the State of California celebrated the opening of the school. (Eileen Kahn Photograph.)

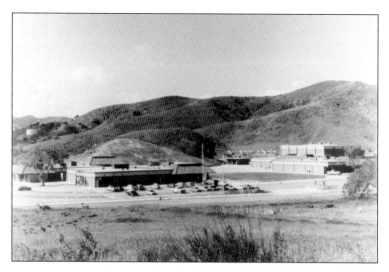

FIRST HIGH SCHOOL BUILDINGS, 1981. The original facilities of Oak Park High consisted of two classroom buildings (on the left and right in this photograph), the school's administrative offices (in the center), and the gymnasium (on the right, behind a classroom building). (OPUSD.)

ALMA MATER PROUD AND BOLD

Proud and bold the Oak Park Eagles,
 spirit soaring high....
Brown and gold our colors flowing,
 honor never die.
Oak Park, Oak Park, ever loyal,
 trees of strength on green hills lie.
Let our love be everlasting,
 onward Eagles fly!

HIGH SCHOOL ALMA MATER, 1983. When the high school was in its infancy, a contest to write the alma mater took place, and junior Ilana Kern won with her lyrics about the Oak Park Eagles. The alma mater was tweaked slightly when the football uniform colors changed from brown and gold to black and gold. (OPUSD.)

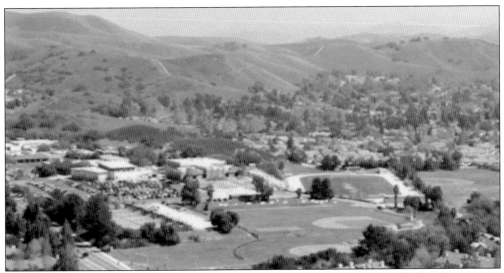

WHERE EAGLES PLAY. The high school teams are called the Eagles, named after the majestic raptors that soar above the surrounding Simi Hills. A major nesting area for golden eagles can be found in the hills on the top right. In the foreground are the softball and baseball diamonds, where the school's Oak Park Eagles play. (OPUSD.)

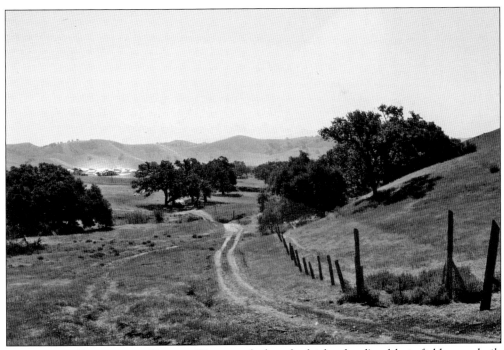

MEANWHILE, BACK AT THE RANCH. Ten years before the high school's athletic fields were built near the corner of Oak Hills Drive and Kanan Road, ranch posts still dotted the landscape. Homes can be seen in the distance on the left. (Richard W. Smith.)

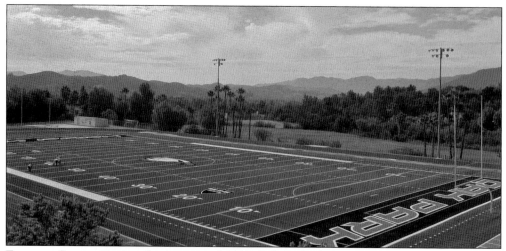

FIELD OF GREEN. During the summer of 2011, Oak Park High School installed high-quality synthetic grass on the football field. This turf upgrade dramatically reduces water usage while providing a great-looking field for the athletes. The school district won an award during that same year for green practices. (OPUSD.)

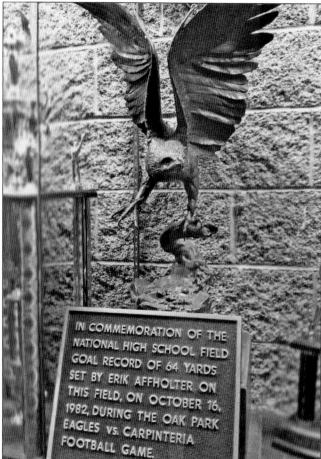

A STAR KICKER COMMEMORATED. A 64-yard field goal was kicked by Oak Park student Erik Affholter during a game in the 1980s, breaking all national high school records. This plaque in the Oak Park High School gymnasium honors this record-breaking event. (Harry Medved.)

OAK VIEW. Located on the same site as the OPUSD Support Services Center and District Office, Oak View High opened in the 1980s as an alternative school meeting the diverse needs of students who are behind in credits and require a smaller, personalized environment to succeed in their education. Many Oak View High students go on to post-secondary education and productive careers after graduation. (Photograph by David E. Ross.)

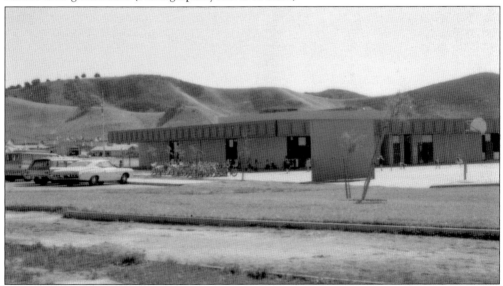

BROOKSIDE ELEMENTARY, 1970S. Brookside was built in 1968 and was the first school built in Oak Park. Originally part of the Simi Valley Unified School District, Brookside was still the only school in the community when voters created the OPUSD. Indeed, that lack of other schools was the primary reason the community seceded from the Simi Valley Unified School District to form its own school district. After the 1977 victory, it became part of the Oak Park district. (Tom Reyes.)

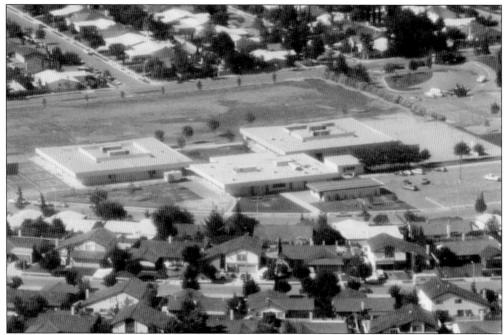

BROOKSIDE ELEMENTARY AND MAE BOYAR PARK, C. 1981. Brookside and Mae Boyar Park were in the center of early Oak Park and walking distance from all of the residences. In this aerial photograph, the temporary administrative headquarters of the Oak Park Unified School District is the small building in front, while the parking lot and tennis courts area of Mae Boyar Park are to the right. (OPUSD.)

BROOKSIDE ATHLETIC FIELDS, 2011. Today, Brookside play fields serve the entire neighborhood—not only the school's programs, but the community in general. Both youth and adult soccer games are played on the two fields at Brookside. (OPUSD.)

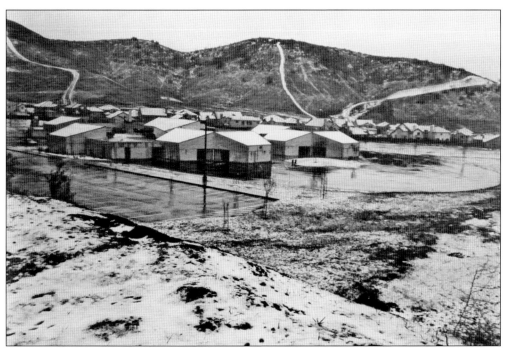

SNOW DAY AT OAK HILLS, LATE 1980s. A new blanket of snow covering this elementary school's buildings is a rare occasion. However, a seasonal carnival held by the Oak Park Neighborhood School on the same campus brings tons of snow for winter play each year. (OPUSD.)

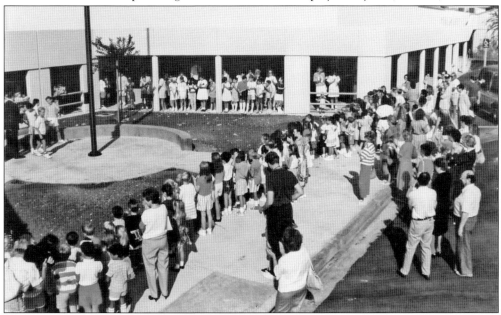

OAK HILLS ELEMENTARY SCHOOL, OPENING DAY. Built in the 1988, Oak Hills was the second elementary school to be constructed in the area, after Brookside. The school's second principal was Dr. Tony Knight, who would later become the superintendent of the Oak Park Unified School District. Dr. Knight has been with the district for more than three decades and helped bring national attention to the schools for their academic excellence. (OPUSD.)

BACK TO SCHOOL. Oak Hills always finds a way to make learning fun. Here, children participate in a Back-to-School Picnic and Dance-a-Thon. (OPUSD.)

RED OAK ELEMENTARY CAMPUS. The district's third elementary school, built in 1994, features plenty of kid-friendly and kid-generated artwork, including this colorful map of the 50 states. (Brian Rooney.)

RED OAK: WHERE LEARNING BEGINS. Like all of the schools in the district, Red Oak is a California Distinguished School. It has an excellent Discovery Kindergarten program for children born between the months of July and December. (Brian Rooney.)

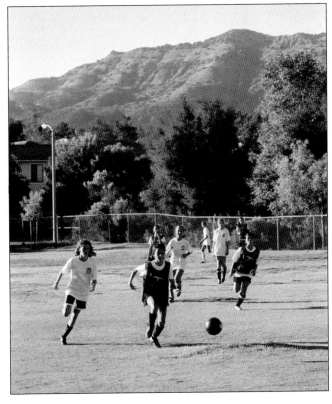

RED OAK ATHLETIC FIELD. Soccer teams play at Red Oak with Simi Ridge as a backdrop. As part of the Oak Park plan, the school athletic fields adjoin the community parks to encourage the kids to stay physically fit and for the convenience of working parents picking up their kids. (Brian Rooney.)

YOUNG ARTISTS AT WORK. Located on the Oak Hills campus, the Oak Park Neighborhood School started with funds from a tobacco tax. The preschool allows children to express themselves in their own unique ways with various artistic activities. (OPUSD.)

SCHOOL DISTRICT HEADQUARTERS. The Support Services Center, which houses the district's administrative offices, was built in 1986 at the corner of Conifer Street and Medea Creek Lane. Reflecting the district's priority for serving students, the headquarters was built only after the high school was finished. (David E. Ross.)

Five

THE HILLS ARE ALIVE
Parks, Recreation, and Trails

Oak Park is surrounded by rolling hills, with 16,000 acres of protected lands owned by the Rancho Simi Recreation and Park District and the US National Park Service and 50 miles of public trails throughout the Simi Hills.

According to 2007 environmental impact report, "The Simi Hills are an area of national significance that is uniquely available to and greatly enjoyed by the residents of Oak Park."

Nestled in the hills are six distinctive neighborhood parks and playgrounds maintained by Rancho Simi Recreation and Park District (RSRPD). They are Mae Boyar, Chaparral, Deerhill, Indian Springs, Valley View, and Eagle View. The much larger Oak Canyon Community Park features a community center, large pond, waterfall, creek, splash pad, archery area, picnic area, amphitheater, and dog park. Medea Creek Natural Park contains an all-weather pedestrian/ bike path and 20 Advanced Challenge Course fitness stations situated alongside a natural stream.

The district also maintains many trails in the open space, with names like Wistful Vista, Sunrise Meadows, Rock Ridge and Canyon Cove.

As part of a 1974 settlement with Ventura County to build more homes, Metropolitan Development Corporation entered into an agreement with RSRPD to provide nearly $2.3 million for recreational development within the community, "offering residents a highly desirable level of facilities and one that will probably greatly exceed recreational opportunities found in many established communities."

Thanks to folks like Don Hunt and Walt Rauhut at RSRPD, and planning consultant Richard Warren Smith, and others, more than 1,500 acres of parks and open space function as "a network of parks" and "an integral component" of the community, according to the 1974 plan. Parks and open space together made up nearly 52 percent of the Oak Park plan. Smith's goal was to "establish a harmonious relationship between the natural park areas and the surrounding streets and residential development." He certainly succeeded, helping make the community a boon to anyone who loves the great outdoors and winning a Progressive Architecture (P/A) Award in Urban Design for his Oak Park work.

The National Park Service and other agencies help maintain some of the adjacent lands that border Oak Park on the north and east. These include such destinations as China Flat and Palo Comado. Much of this land was owned at one time by entertainer Bob Hope; through the tireless efforts of local activists, the rolling foothills, oak savannas, sandstone cliffs, and hidden canyons were eventually preserved as wilderness for the public to enjoy. The folks who helped save the nearby Jordan Ranch wilderness included Mary Wiesbrock, Margot Feuer, Sue Boecker, Jeanne Cope, Rosie McCabe, Ginger Pollack, John Perry, Gary Boyle, Brad Childs, Elois Zeanah, Cassandra Auerbach, Carrol McDonald, Siegfried Othemer, Bob Coutts, Molly Jordan, actors Barry and Dick Van Dyke, and many others.

As Conejo Post blogger and wilderness activist Janna Orkney points out, "Oak Park is one of the few SoCal communities where you can walk outside your home and into thousands of acres of protected national park service land."

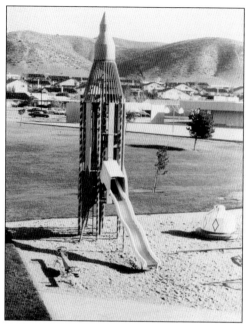

MAE BOYAR PARK, LATE 1960s. Named for the late wife of Oak Park developer Lou Boyar, the first park in the community was dedicated on November 15, 1966. Boyar donated the land, plus $140,000 for park improvements. The playground was built next to the future site of Brookside Elementary School, and these two facilities served as the center for community activities for many years. The two other elementary schools in Oak Park also enjoy adjacent neighborhood parks. (RSRPD.)

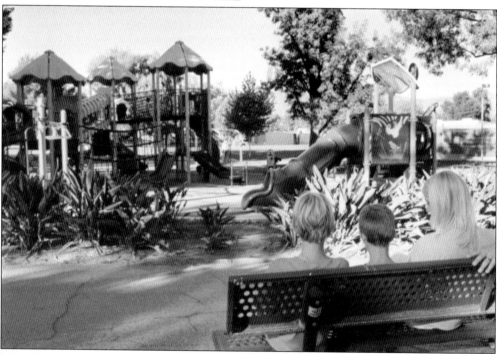

MAE BOYAR PARK, 2011. The rocket slide structure was a big hit with neighborhood kids but was later dismantled for safety reasons. Rancho Simi Recreation and Park District replaced it with more durable play equipment in the 1990s and again in 2006. According to resident Barbara De Minico, "there are so many delightful things about Mae Boyar Park. My earliest memories includes the horseshoe pits—a throwback to the old ranching days of the area—and the beautiful cedar waxwings that feasted on the pyracantha berries from the bushes lining the park and that appeared every winter like clockwork." (Brian Rooney.)

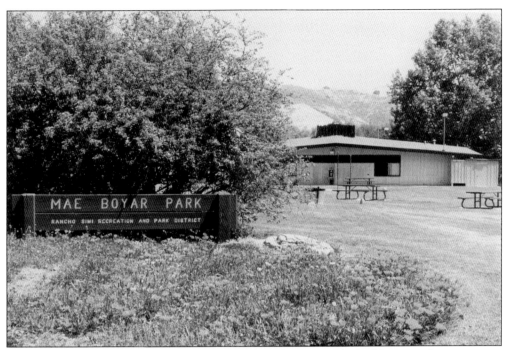

MAE BOYAR RECREATION BUILDING, 1966. Oak Park's first public building was this recreation facility built in 1966 by the Simi Valley Recreation and Park District. The agency was later renamed Rancho Simi to help Oak Park residents realize that the district represented them as well. This center was frequently used for community meetings and park activities. (RSRPD.)

MAE BOYAR RECREATION BUILDING, 2011. This center is still a popular meeting place today, providing activities for youth, including the AM/PM Club (before- and after-school programs), soccer, volleyball clinics, and rental space for birthday parties. The park is also popular for its two lighted tennis courts. (Brian Rooney.)

CHAPARRAL PARK, 1970S. Coauthor David Ross, who helped name this parcel, poses among the newly planted trees at the dedication of the community's second neighborhood park at 217 Medea Creek Lane near Conifer Street. Ross suggested the name of the park after the Chaparral Homes development nearby. (Ross Family Archives.)

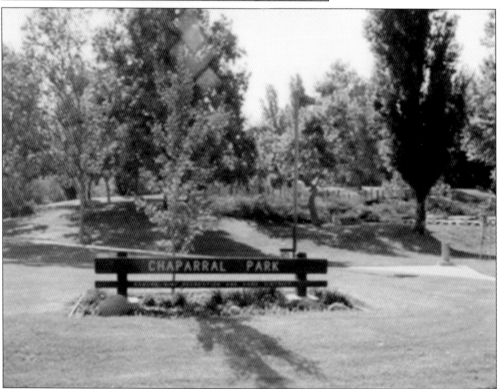

CHAPARRAL PARK, LATE 1990S. Two decades later, the park's sycamores, oaks, pines, and other trees became towering shade trees that surround the park's two playgrounds and walking path. (RSRPD.)

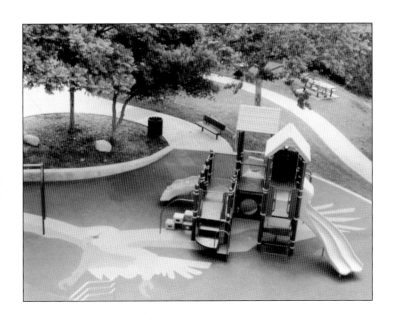

EAGLE VIEW PARK. Located in the Sutton Crest hills near the northern tip of Oak Park, this 1989 neighborhood playground offers an enticing view of the Santa Monica Mountains to the south. The park's secret footbridge spans Medea Creek and leads to a leafy glen. From here, one can take the trail north to China Flat or head south along the bicycle path into Oak Canyon. (RSRPD.)

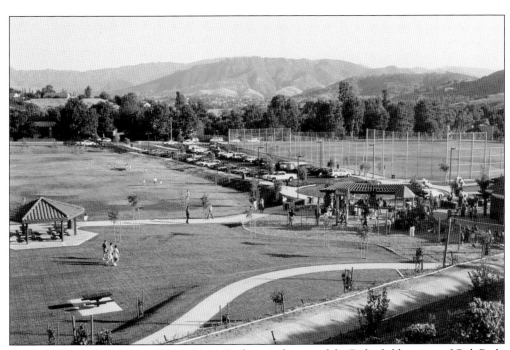

DEERHILL PARK DEDICATION DAY, 1990s. Built near the top of the Ridgefield section of Oak Park, this park features a playground, softball and soccer fields, tennis and basketball courts, and picnic areas. Agoura's Ladyface Mountain looms over the park in this photograph. (RSRPD.)

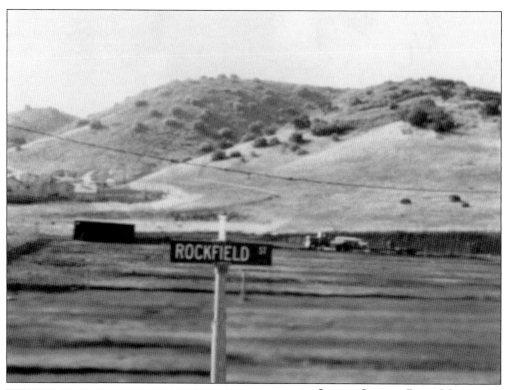

INDIAN SPRINGS PARK, MID-1990s. Construction begins on the future neighborhood park and playground, dedicated in 1995, at the southwest corner of Rockfield Street and Hawthorne Drive. The park's name may refer to the Native Americans who camped at the springs in the nearby Simi Hills. (OPUSD.)

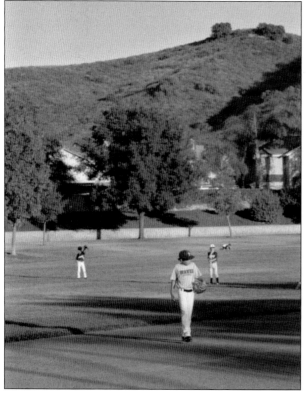

INDIAN SPRINGS PARK, 2011. The popular baseball field at the park adjacent to Red Oak Elementary gets a workout from fans of America's greatest pastime. The park highlights include toddler- and infant-friendly playgrounds, basketball and tennis courts, and a jogging path with exercise stations. (Brian Rooney.)

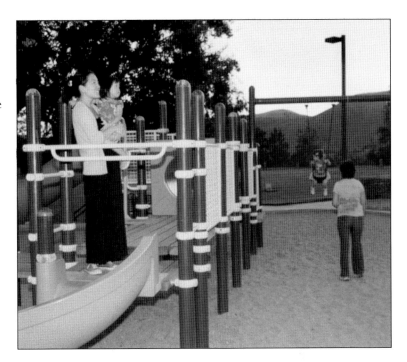

VALLEY VIEW PARK. Adjacent to Oak Hills Elementary School and the nearby Episcopal church, this 8.3-acre park is aptly named, as it is nestled below Oak Park's rolling hills. Kids of all ages enjoy the playground, ball courts and fields, and the grassy expanses. Valley View was dedicated in 1992. (Brian Rooney.)

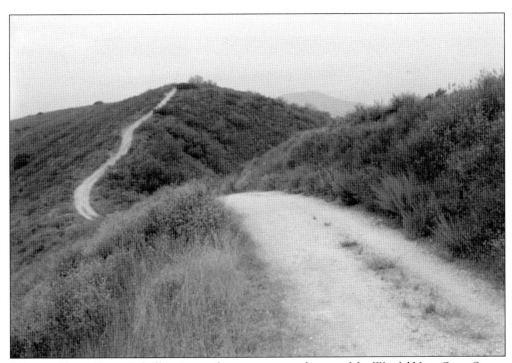

WISTFUL VISTA. Several challenging trails converge near the top of the Wistful Vista Open Space, rewarding hikers with sensational views of the Santa Monica Mountains and the Simi Hills. Wistful Vista was named after the fictional street and community of radio's famed suburbanites Fibber McGee and Molly, played by Jim and Marion Jordan, Oak Park's prior landowners. (Brian Rooney.)

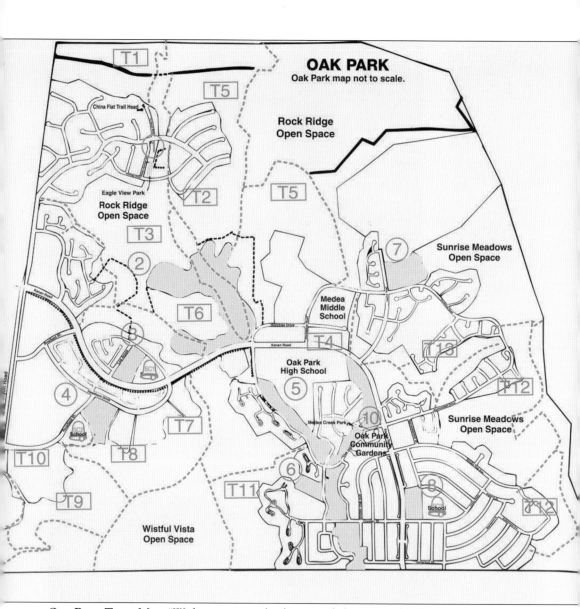

OAK PARK TRAIL MAP. "We have more parks than people here," says local hiker and biker Robert Fried. "Once you get on the trail, you're suddenly smack dab in the wilderness. You can walk from anywhere in Oak Park to a charming playground, which is a huge plus to any parent." Rancho Simi administers the land and takes care of the parks and trails. (RSRPD.)

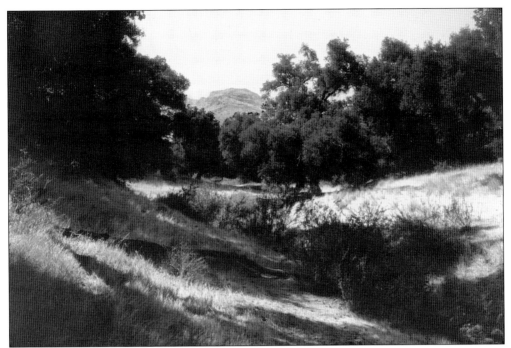

A RIVER RUNS THROUGH IT. The creek environs were even wilder prior to the development of the Medea Creek trail through the heart of Oak Park. Today a scenic, all-weather pedestrian/bike path parallels the watercourse from Eagle View Park to the L.A. County Line. Simi Ridge can be seen in the distance in this 1970 photograph. (Richard W. Smith)

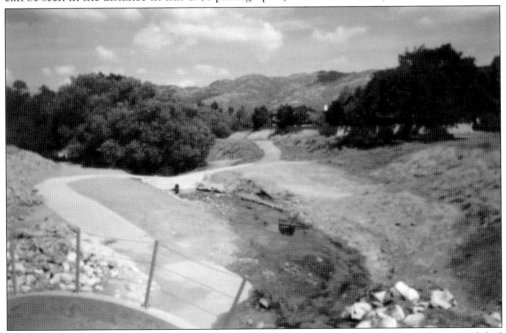

MEDEA CREEK NATURAL PARK, 1980s. The banks of this year-round creek have been modified with boulders south of Oak Hills Drive for flood protection. The course of the creek is today maintained as a 1.9-mile-long natural linear park. (Tom Reyes.)

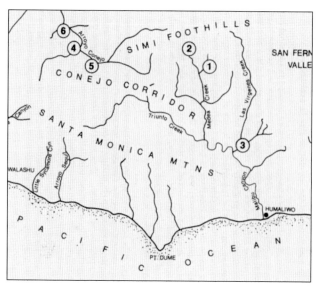

MEDEA CREEK TO THE PACIFIC. Oak Park residents have a great responsibility to keep their sidewalks clean and ensure that pollutants do not enter the runoff water that eventually winds its way down to the Pacific Ocean. Medea Creek and its tributaries start out as a spring near the top of Simi Ridge, near sites number one and two on this map. It cuts through Oak Park, Agoura Hills, and Paramount Ranch and ends in Malibou Lake. From the lake dam, Malibu Creek continues it course through Malibu Canyon as it heads to the ocean at the Malibu Lagoon. (UCLA.)

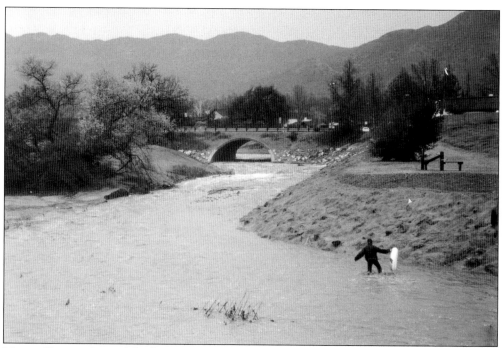

MEDEA CREEK, 1980s. After big storms, the normally peaceful little creek resembles a river. This shot was taken after a heavy rainfall, with the swollen banks of the creek just south of Conifer Street. The County of Ventura and OPUSD installed a unique filtration system in this area in 2009 and 2011, using plant roots, soil, and gravel. (Tom Reyes.)

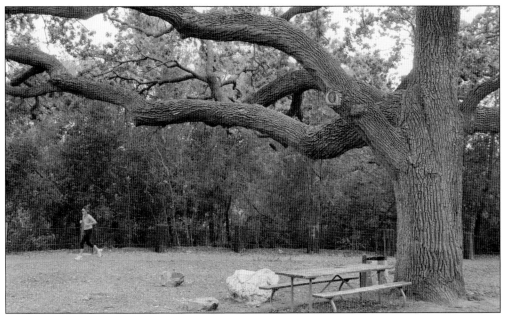

MEDEA CREEK TRAIL, 2011. This suburban greenbelt features a jogging, dog-walking, and biking path shaded by multibranched oak trees. This picnic table on Medea Creek provides a rest stop along the path, where walkers can stop and watch the woodpeckers hammering away at this centuries-old oak tree. The trail's challenge course takes fitness lovers to such exercise stations as a scaling wall, chin-up bars, and monkey bars. (Greg Tucker.)

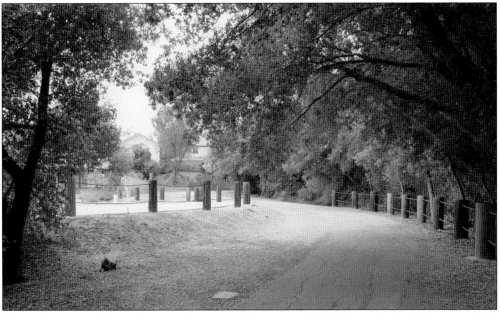

TRAIL POST-AND-CABLE FENCING LINE THE PATHWAYS, 2011. Electrical utilities were built underground in Oak Park, so there was no need for telephone poles in the community. Throughout the neighborhood, old telephone poles line the rustic walkways among the oaks behind the houses. This trail along Medea Creek East serves as a pedestrian path connecting the homes with the library and high school. (Greg Tucker.)

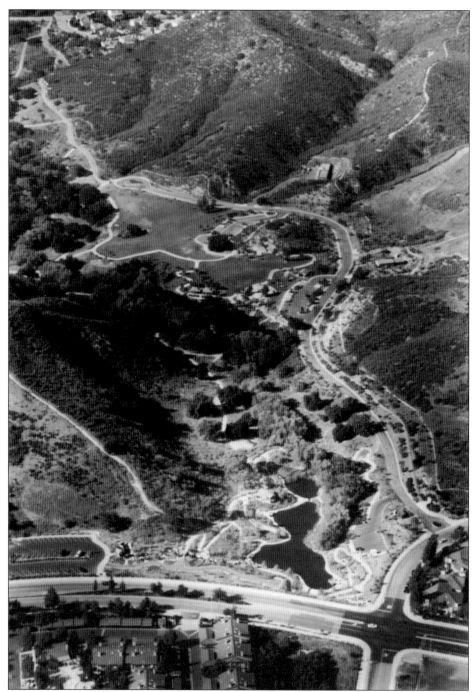

AN AERIAL VIEW OF OAK CANYON. An aerial view shows Oak Canyon's extensive trail network extending from the pond at the corner of Kanan Road and Hollytree Drive to the Simi Hills in the north. Originally known as Oak Canyon Community Park and Lagoon, this picturesque property is in the heart of Oak Park and was named by a young local student in a competition. The park's original name, Rustling Oaks, was deemed too confusing because of a street with the same name in Agoura Hills. (RSRPD.)

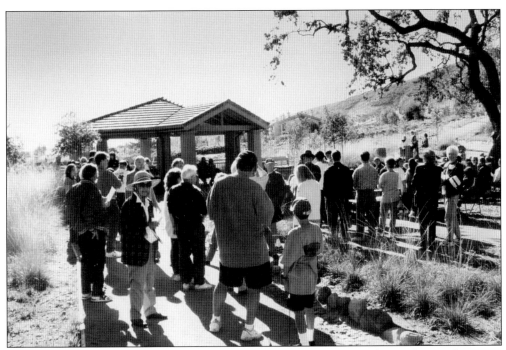

OAK CANYON DEDICATION CEREMONY, 1990s. Community residents gather at the grand opening of the pond overlook and lower picnic area, a future site for weddings and birthday parties. The park covers dozens of acres of open space and developed facilities. (RSRPD.)

OAK CANYON BRAILLE TRAIL. Pictured here is a trail for the blind that circles the pond at Oak Canyon Community Park. An interpretive nature trail goes farther into the woods, ending at Bromely Avenue. (RSRPD.)

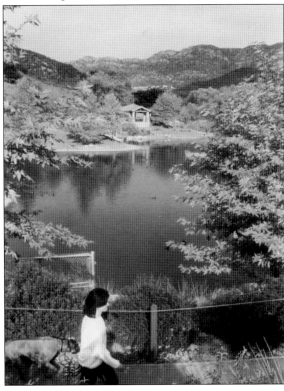

WELCOME TO OAK PARK FALLS. One of Oak Canyon's many attractions is this man-made recirculating and cascading waterfall that provides a scenic setting for the park and helps aerate the pond water. At one time, engineers suggested paving a road through this lush canyon from Kanan to Bromely Avenue. "Luckily we were able to preserve its natural beauty," recalls Don Hunt of RSRPD. "Oak Canyon is the jewel of the community." (Greg Tucker.)

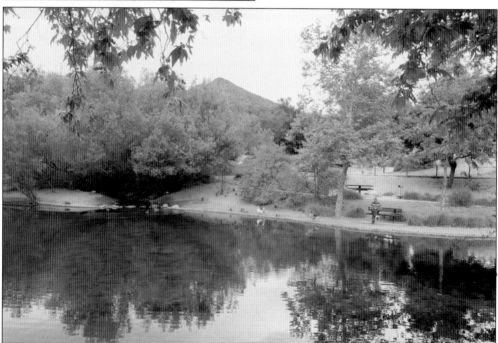

PEACE AND QUIET. The Oak Canyon duck pond makes for a shady, tranquil respite from city life, surrounded by willows, oaks, sycamores, and cattails. (Greg Tucker.)

A Birding Paradise. In this photograph, a heron rules the roost on a tree branch overlooking Oak Canyon. A trail that circles the pond provides opportunities for seeing herons, egrets, coots, hawks, mallards, geese, and owls. Wildlife fans will see lots of bunnies, too, as Oak Park abuts the aptly named Conejo Valley (*conejo* is Spanish for "rabbit"). (RSRPD.)

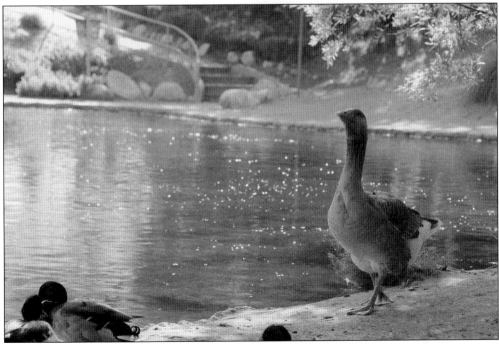

Oak Park's Legendary Mother Goose. A fearless greylag goose (the same species that served as the model for *Mother Goose* of storybook fame) once stood guard in 2011 to help protect the other waterfowl at the Oak Canyon Community Park pond. (Greg Tucker.)

COOL SUMMER. The Oak Park Splash Pad, installed in 2010, has been a big hit with kids of all ages. It is currently open from Memorial Day to the end of September. (Greg Tucker.)

SPLASH PAD. This Oak Canyon attraction is a favorite kids' birthday party destination. (Greg Tucker.)

DOG TALES. The Oak Canyon Dog Park opened on the former site of the archery range in the spring of 2010 with much excitement. On any given day, one can find an abundance of dog breeds along with residents of the community swapping stories of the week. (RSRPD.)

OAK PARK STAR PARTIES. Oak Canyon Community Park is one of the finest places near the Los Angeles area to see the stars, says astronomy buff Pascal Menut. "Due to the bowl shape of high hills wedged over the canyon," says Menut, "the lights from the city are blocked out, with only a fraction of 'light pollution' affecting the sky. The proximity to the ocean also makes it one of the best places to see the Milky Way, the moons of Jupiter and countless attractions in the night sky." (Woodland Hills Camera & Telescopes.)

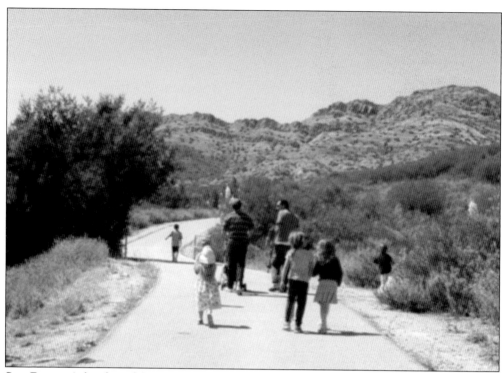

SIMI RIDGE. A family and friends head up the paved bike path skirting Oak Canyon Community Park towards the familiar Western backdrop of Simi Ridge. (Greg Tucker.)

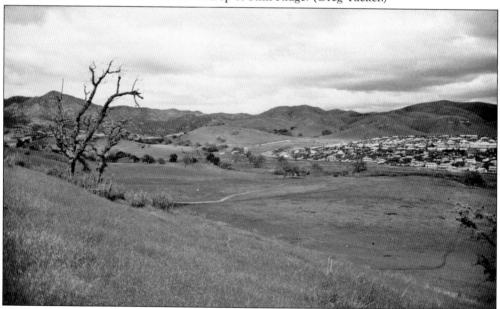

DOWN IN THE VALLEY, EARLY 1970s. Oak Park hikers are treated to views of the grasslands, rolling hills, broken hills, creekside ponds, and oak woodlands. According to architect Richard Warren Smith, "one previous plan for the community aimed to cut the hills and fill the valleys to produce a level site for homes. Oak Park would have looked as flat as the landing pad on an aircraft carrier." (Richard W. Smith.)

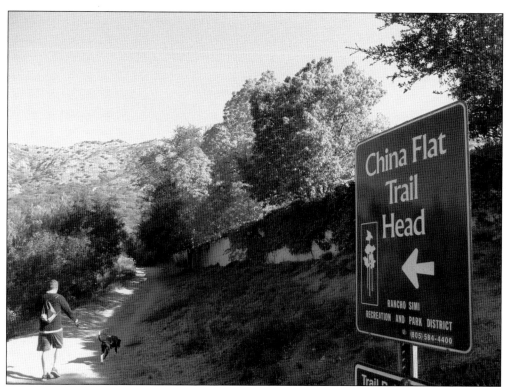

THE TRAIL TO CHINA FLAT. Although it has never been verified, local legend has it that Chinese railroad workers developed a hilltop encampment here during the era of the Chinese Exclusion Act in the 1890s. This is why this area is named China Flat. According to veteran Simi Valley resident Mike Kuhn, who found Chinese porcelain in the area, "The Chinese could not own land, become citizens, or marry Anglos at the time. As a result, there was a considerable underground traffic, and it is possible that this area was used for the movement of labor through the high country to avoid detection. Many Chinese workers were employed to help build the Santa Susanna Pass Tunnel." (Harry Medved.)

MAN WITH A PLAN. Dr. Richard Warren Smith conceptualized Oak Park's natural parks system, roadways, and open space in the 1970s. According to Dr. Smith, the community may have been one of the first to be planned with an Environmental Impact Report, a new concept at the time. (Richard W. Smith Collection.)

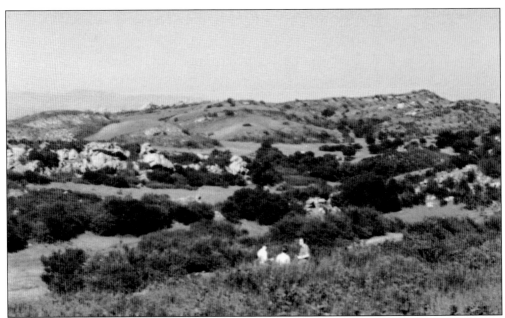

CHINA FLAT, 1960s. A favorite destination for mountain bikers, China Flat features a surprising amount of greenery amongst an oak savanna hidden near the top of rugged Simi Ridge. Here, a family surveys the area in the 1960s. (Las Virgenes Historical Society/Agoura Hills Library.)

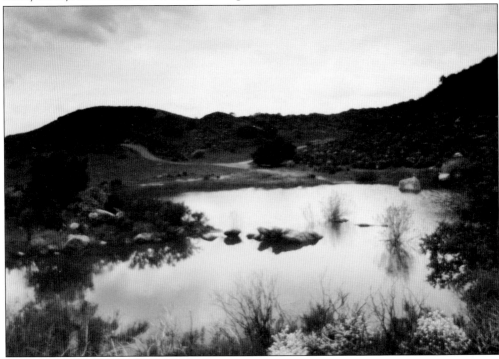

CHINA FLAT POND, 1980s. Hikers will find a sage-covered oasis and an often dried-up watering hole at what was once ranchland near the top of Simi Ridge. The Jordans held onto this portion of their ranch—1,100 acres of China Flat—until the early 1960s. Bob Hope, who previously purchased Palo Comado from the Jordans, bought China Flat too. (National Park Service.)

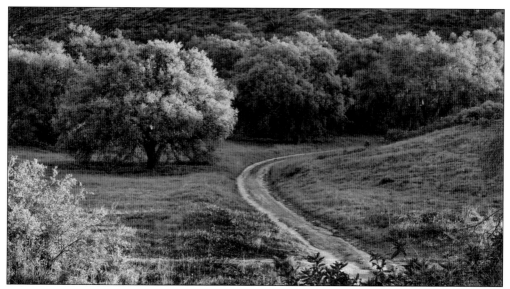

CHINA FLAT TODAY. Bob Hope, who previously purchased Palo Comado from the Jordans, bought China Flat from them around 1960. Gossipers claimed that Hope planned to build a private airstrip at the 2,140-foot plateau, although that story has never been substantiated. Today, it is a remarkably green oak tree haven with beautifully curving biking and hiking trails (like the one in this photograph) and incredible views. (Jim Bass/BassImages.com.)

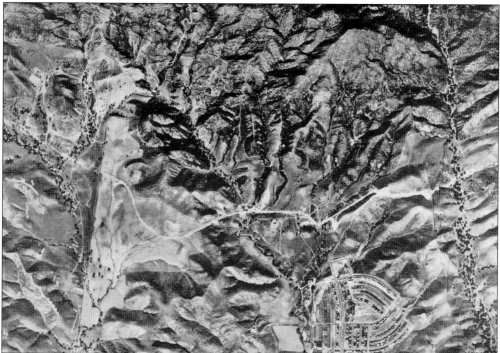

THE GRAND CANYONS OF OAK PARK. The community is wedged between two canyons, Lindero on the left and Palo Comado on the right. Medea Creek courses through a third, named Oak Canyon, in the middle. China Flat is hidden behind the folds of the sandstone cliffs near the top of this early 1970s photograph. (Richard W. Smith Collection.)

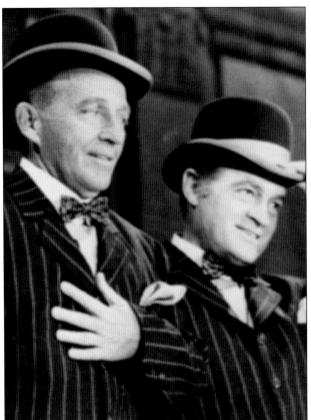

BING AND BOB. According to a March 7, 1990, story in the *Los Angeles Times* by Alan Citron, "Legend has it that [Bob Hope] and his close friend, Bing Crosby, once stood atop the China Flat parcel and mused over the possibilities of developing it into a second Bel-Air." Luckily for outdoors enthusiasts, Hope never developed the land. According to former Oak Park MAC chair and county supervisor aide Ron Stark, "We had heard the rumor that Hope was planning to build his own private airstrip on China Flat, so that he could easily fly to his property, while Crosby would have to drive there." (Bison Archives.)

TOP OF THE WORLD. Hikers at the top of 2,403-foot-high Simi Peak, the highest peak in the Simi Hills, are rewarded with a sensational view of the Oak Park environs and, on a clear day, the Pacific Ocean. (Harry Medved.)

PALO COMADO GRANT DEED, 1955. The top radio comedy stars of the 1940s, Fibber McGee and Molly (Jim and Marian Jordan) and Bob Hope became rancher neighbors after the Jordans sold Hope a 1,695-acre portion of their ranch on August 3, 1955. Hope's parcel (depicted on this map) later became known as the Jordan Ranch, but today it is called Palo Comado Canyon. Jim and Marian's son Jim Jordan Jr. had directed Bob Hope's USO shows and some of his television specials from 1953 to 1955. (Ventura County Records.)

FORE! Hope originally planned to sell his Palo Comado holdings to developers wanting to build a PGA golf course and more than 1,152 luxury homes on the site. Today, the land has been preserved as open space forever, due to the efforts of Save Open Space/Santa Monica Mountains and other lobbying groups. Because of his reluctance to sell land to low bidders, Hope ended up—whether or not it was intentional—as one of the largest providers of open space in the Santa Monica Mountains National Recreation Area. (Bison Archives.)

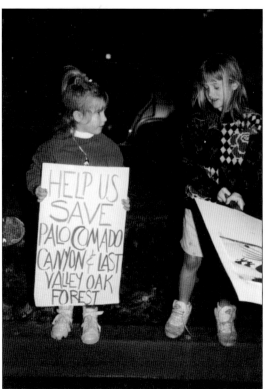

KIDS SAY THE DARNEDST THINGS. Local Oak Park and Agoura children Ali Boecker (left) and Katy Wiesbrock join the fight to preserve Palo Comado's natural habitats. Today, Oak Park residents enjoy two entrances to the canyon: on Doubletree Road and on Smoketree Avenue. (Mary Wiesbrock.)

PALO COMADO CANYON, SUNNYCREST/ DOUBLETREE TRAILHEAD. Mary Wiesbrock (left) and Molly Jordan, two activists who helped preserve this wilderness, take a stroll into Palo Comado Canyon, near the cattle gates that bear testament to its former incarnation as part of the Jordan Ranch. In 2005, plans for a 2-million-gallon water tank at this site were stopped by activists, leaving a pristine view of the wilderness for neighbors, hikers, and bicyclists. (Janna Orkney/ConejoPost.com.)

A WALK TO EDEN. An Oak Park mother and daughter hike the connector trail to verdant Palo Comado Canyon. This wild land fronting Palo Comado Canyon on the west is known as Sunrise Meadows Opens Space and can be found at the eastern end of Smoketree Avenue. (Brian Rooney.)

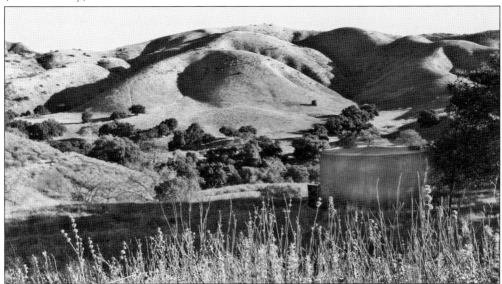

A RANCH ARTIFACT FROM THE 1950s. There are vestiges here and there—like this water tank built adjacent to Oak Park in August 1951—that bear testament to the area's previous incarnation as an extensive cattle ranch. In 1985, when Bob Hope still owned Palo Comado, a herd of cows managed to get through the ranch's fence and wandered onto the high school football field, with some "kids on bikes getting chased by cows," according to school district manager Rob Corley. Hope's cows caused $35,000 worth of damage, which the entertainer paid. (Brian Rooney.)

AMONGST THE OAKS. A hiker is dwarfed by hundreds of ancient oaks that surround the six-mile trail in Palo Comado Canyon. At one time this canyon was considered a prime spot to develop as a golf course, luxury home community, and early on, a prison site. Today, it has been preserved by the National Park Service as part of the Santa Monica Mountains National Recreation Area. (Brian Rooney.)

UPPER PALO COMADO CANYON. Strikingly unusual stone formations stand guard over the demanding trail from Palo Comado Canyon to China Flat. Hikers can also traverse the hills from here to Cheeseboro and Las Virgenes Canyons. (Harry Medved.)

Six

Our Town and Cultural Life
Celebrations and Institutions

Oak Park provides ample opportunities for cultural and social activities. The neighborhood includes a community center, gardens, a library, and four different houses of worship.

The Oak Park Library is an unusual combination of public and high school library, operated jointly by Oak Park High School and the Ventura County Library System. The striking structure includes special bricks that keep the cold air out during the winter months and keep the heat out during the summer.

Athletic fields at schools and parks provide venues for organized sports—softball, baseball, and soccer—for Oak Park youth. The Community Garden has over 60 garden plots for adults to raise organic vegetables and flowers. The Rancho Simi Recreation and Park District supports cultural and recreational events and activities at the Oak Park Community Center and in its developed parks within the community.

The early-1970s plan for Oak Park called for a community center that included the high school, middle school, and library, all of which were built nearby. Other community center facets, like a retail area and office space, were moved to the Lindero-Kanan area when commercial centers were built in the 1990s.

Over the years, the community has turned down plans for gas stations, liquor stores, and 24-hour convenience marts (along with requests for gated subdivisions) to help maintain a certain quality of life, avoid urban blight, and create a sense of unity and small-town charm.

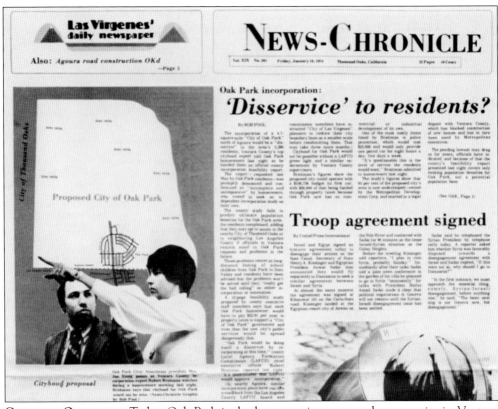

CITYHOOD QUESTIONS. Today, Oak Park is the largest unincorporated community in Ventura County, but in 1974, a preliminary study for creating a city was considered. It ended with a negative report. The issue was revived in the 1980s, when an advisory election was conducted. "Remain unincorporated" was the majority opinion, followed by "incorporating as a city" and "annexing to the city of Thousand Oaks" (a distant third). (Bob Pool.)

BIG MAC, 1975. A community sign proclaims the first meeting of the "Proposed New Advisory Council." Ron Stark, the first chair of the Municipal Advisory Council (MAC), recalls that "Oak Park was created by a series of fortuitous events, some of which didn't seem so wonderful at the time. The community was built by the people who lived in Oak Park, thanks to the MAC working with—and sometimes fighting with—the developer and county." (Richard W. Smith.)

NEW ZIP CODE. For years, people assumed that Oak Park was located in Los Angeles County because it shared a zip code with neighboring Agoura Hills. This affected sales tax on major items, insurance costs, and more. After a long struggle, the US Postal Service created a new zip code exclusively for Oak Park (91377), which was implemented on January 1, 1999, as notified in this letter. The new code clearly indicated that the community was in Ventura County, helping save residents from paying higher costs. "We fought for financial reasons," recalls activist Steve Iceland. "But the new zip also helped reinforce our civic pride as an independent community with the natural beauty, peace, and great quality of life." (Russell and Julie Paris Collection.)

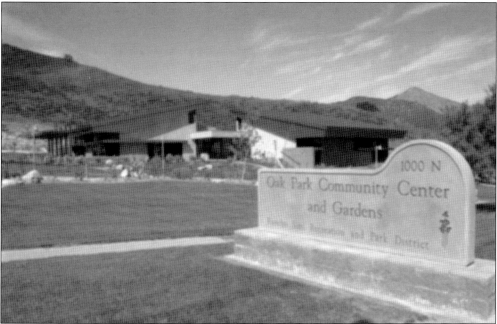

OAK PARK COMMUNITY CENTER. A high-priority facility since 1979, the community center finally opened in 2004 at the southwestern end of Oak Canyon Community Park. Today, it is the heart of the community, providing a home for programs like mommy and me classes, aerobics, adult basketball league, an archery range, and a rental hall for family celebrations. (Harvey Kern.)

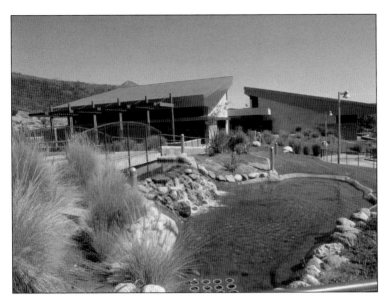

THE GARDENS AT THE OAK PARK COMMUNITY CENTER. Besides the main building seen here, a smaller building is equipped for children to engage in arts and crafts. There is also a wedding gazebo. (Harvey Kern.)

FIRST LIBRARY. A sign points to the original library location on the high school campus. It was little more than one large room. The space is now occupied by classrooms. (OPUSD.)

TODAY'S OAK PARK LIBRARY. One of 13 branches in the Ventura County Library System, Oak Park's modern-looking library (which some have likened to an airport tower or lifeguard station) opened in 2004. It is a joint venture of the high school and the county library system and is open to students and adults alike. "The library is one of our proudest achievements," says former Oak Park MAC chair Ron Stark. "We wanted something that would blend in with the high school and would provide views of the mountains, something functional yet pleasing to the eye." The architecture firm Fields Devereaux won a 2003 award for this building's innovative design and library solutions. (David E. Ross.)

OAK PARK COMMUNITY GARDEN. In 2003, a group called the Oak Park Gardeners got together with the purpose of establishing an organic community garden where individual members can grow vegetables or flowers of their choice. They brought life to a vacant dirt lot at the corner of Kanan Road and Sunnycrest Drive. Near this spot in the 1960s was a trailer where early Oak Park site manager Dan Lavetts (Mae Boyar's nephew) watched over the houses before they were sold. (Greg Tucker.)

THE CHURCH OF THE EPIPHANY. This Episcopal church has been part of Oak Park since the 1980s. Its first meeting was held on the Feast of the Epiphany, January 6, 1980. The church's Hook organ has 936 pipes and dates back to 1869. When it was installed in 1999, it was speculated to be the oldest unaltered two-manual pipe organ in California. (David E. Ross.)

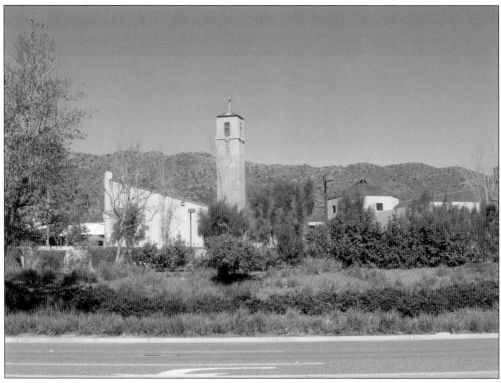

ST. MAXIMILIAN KOLBE CATHOLIC CHURCH. Called "St. Max" by its parishioners, church services were originally held in various Oak Park locations—including Oak Hills Elementary in 1989—before the church facilities were built in the neighborhood of North Ranch. The current church was completed in 2000, and a small slice of its parking lot is within Oak Park. (David E. Ross.)

MORMON CHURCH. The Church of Jesus Christ of Latter-day Saints, next to Medea Creek Middle School, is one of four religious facilities in the Oak Park area. Sunday school classes are held on the oak-strewn patio, which was an Eagle Scout project by one of the congregants. (David E. Ross.)

CHABAD OF OAK PARK. Oak Park's synagogue, located in a residential neighborhood and along the Medea Creek pedestrian/bike path, serves many Jews of the community. Chabad has been in the neighborhood since the mid-1980s and in this location since the mid-1990s. (Brian Rooney.)

FOURTH OF JULY PARADE AND PICNIC. From the late 1960s until the mid-1980s, the Oak Park Civic Association sponsored an annual parade and picnic on July 4th. At one memorable parade, five-year-old Mary Mike Williams was crowned Miss Oak Park 1968, much to the envy of other five-year-old girls. As a result, this parade feature was soon scuttled. (Tom Reyes.)

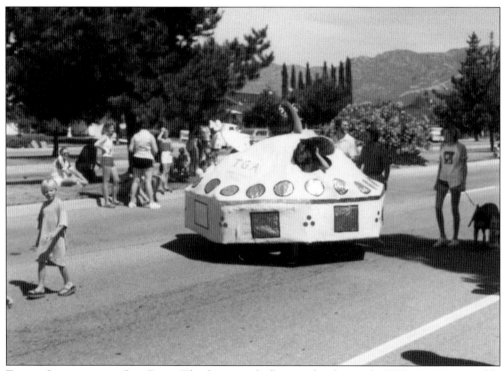

FLYING SAUCERS OVER OAK PARK. This homemade float in the shape of a UFO was a memorable sight. In later years, a national nonprofit liability insurance crisis forced the Oak Park Civic Association to disband and discontinue the annual event. (Tom Reyes.)

HALLOWEEN FOR A CAUSE. Since 2003, the Oak Park Community Garden, at the corner of Kanan Road and Sunnycrest Drive, has opened up its site to the public and sold pumpkins as a fundraiser. (Brian Rooney.)

WINTER HOLIDAY REGATTA. Informally organized by Oak Park residents, this dry-land regatta has paraded through residential neighborhoods since 2000. Lighted boats, towed by cars or trucks, "sail" through the streets of Oak Park with families serenading the neighborhood with holiday songs. (Wayne Blasman Photograph.)

AN EGGS-CELLENT DAY. Every Easter, kids scurry around the grass as part of a massive Easter egg hunt in Mae Boyar Park. Rancho Simi schedules several holiday events for the community each year. (RSRPD.)

HOLIDAYS IN OAK PARK. Holi, an annual Hindu festival signaling the arrival of spring, has been celebrated in Oak Canyon since 2007. India Cultural Society helped parents from Oak Park organize this event, which attracts more than 100 locals each year. During Holi, Hindus attend a public bonfire, spray friends and family with colored powders and water, play games like tug-of-war (seen here), and participate in general merrymaking. (Ragini Aggarwal.)

OAKCHELLA, 2011. The first annual Oakchella music festival was held on May 14, 2011, at the Oak Park High School Football Field, hosted by the Oak Park High School Choir. Roughly 100 people attended this festival to watch several local Oak Park bands, including Bromely, shown above. (Preston Walker.)

MUSIC IN THE PARKS. Several events are presented by the Rancho Simi Recreation and Parks District throughout the year at Oak Canyon Community Park. An Eagles tribute band performs in this photograph. These events occur during spring and summer months. (RSRPD.)

115

HOUSE CONCERT. Locals look forward to the regular events at Russ & Julie's House Concerts. Russ and Julie Paris have hosted many musicians at their Oak Park home, including Karla Bonoff, Jim Messina, Ronny Cox, and John McEuen, pictured here. (Russell and Julie Paris Collection.)

SNOW, 1989. Winters in Oak Park are generally mild. Snow has been seen in the community only three times in more than 35 years, never lasting more than an hour or two. (Russell and Julie Paris Collection.)

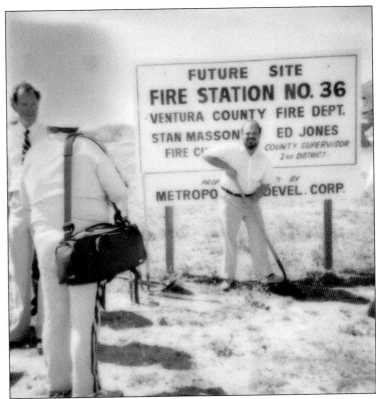

FIRE STATION GROUND BREAKING. Community leaders and MDC officials break ground for Ventura County Fire Station No. 36 in Oak Park in the early 1980s. Coauthor David Ross is seen here with a shovel, while Ventura County supervisor Ed Jones (far left) looks on. (Ross Family Archives.)

OAK PARK FIRE STATION NO. 36. Oak Park is part of the Ventura County Fire Protection District, which also serves six of the county's 10 cities and all of the rest of the county's unincorporated areas. (Ross Family Archives.)

FIRE ON THE MOUNTAIN. The first major fire to strike Oak Park was in 1970, a blaze which caused many in the original Oak Park community to evacuate. This blaze destroyed the ranch house owned by the Jordans. (Alyce Nine Photograph.)

OAK PARK SNAKE GUY. How many communities can boast their own Snake Guy? Bruce Freeman, a financial planner, volunteered his time to relocate snakes that had slithered into suburbia from 1994 to 2012. Bruce says he "started collecting reptiles in 1957, and I'm still at it." (Bruce Freeman Photograph.)

Seven

Hollywood West
Movies Filmed in Oak Park and Environs

Before celebrated performers like Jim and Marian Jordan (Fibber McGee and Molly) and Bob Hope acquired land in the area, Hollywood studios discovered the region as a picturesque Western backdrop, complete with craggy sandstone cliffs, gentle rolling hills, and herds of local cattle already on hand. A real estate brochure for Oak Park's Countryview Homes used its Hollywood heritage as a selling point. "Oak Park's rustic beauty was used as a location for Western films," the advertisement said.

Hollywood came to film scenes on the ranchland's wide-open spaces in the 1930s. Columbia Pictures shot a few of its B-movie Westerns with Charles Starrett here, according to location expert Brent Davis. Future Western director Budd Boetticher worked as a young horse wrangler on the 1939 classic *Of Mice and Men*, reportedly shot near today's Mae Boyar Park. Boetticher returned to the area in 1953 to direct Glenn Ford's *The Man from the Alamo*, shot in the vicinity of what is now Oak Park High School.

The most frequently filmed location was the Western town built in the 1960s near the modern-day intersection of Lindero Canyon and Kanan Roads. Stars such as James Stewart (*The Rare Breed*), Henry Fonda (*Firecreek*), Cliff Robertson (*The Great Northfield Minnesota Raid*), Dean Martin (*Texas Across the River*), and Dustin Hoffman (*Little Big Man*) trod these dusty streets. Episodes of classic television shows like *Gunsmoke*, *Wagon Train*, *The Big Valley*, and *Bonanza* were reportedly shot here too.

Alternately known as North Ranch, Sutton Ranch, and the Ghost Town, this Western set was left in a state of disrepair as the demand for Westerns diminished. Many suburban kids and motor-cross enthusiasts fondly recall tearing through the abandoned sets, which were eventually torn down in the 1970s.

Later films shot in the area included *Nickelodeon* (in which Burt Reynolds films a movie on an ostrich farm), *Back to the Future 3* (in which Michael J. Fox visits the McFly Ranch near China Flat), and *Faster* (in which Billy Bob Thornton pays a visit to his strung-out ex-wife living in the Ridgefield development). The Bright Child indoor play area has been a particular favorite for comedies about out-of-touch father figures in *Imagine That* (Eddie Murphy), *Just Go With It* (Adam Sandler), and *Role Models* (Paul Rudd).

Before development, the grassy expanses near North Ranch provided chase-scene settings for diverse films such as *Bonnie and Clyde* (the climactic slow-motion ambush was filmed near the future intersection of Westlake Boulevard and Kanan Road), *Everything You Wanted to Know About Sex But Were Afraid to Ask* (Woody Allen defeats a giant breast-monster in the countryside below Simi Ridge), and *The Thing With Two Heads* (where the motorcycle-riding creature eludes police cars near Medea Creek).

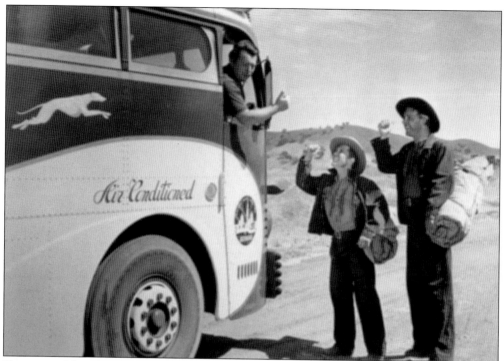

CINEMATIC MILESTONE. Oscar-winning director Lewis Milestone loved shooting his movies in the Agoura/Oak Park/Westlake Village area, according to his associate, actor-producer Norman Lloyd. Here, Milestone (on bus) poses with his stars Burgess Meredith (standing left) and Lon Chaney Jr. (right) for a publicity still for his 1939 version of John Steinbeck's *Of Mice and Men*. According to the January 8, 1940, issue of *Life* magazine, Milestone and company "rented at $25 a day the Agoura ranch of William Randolph Hearst." Camelback Peak and Ladyface Mountain can be seen in the movie behind the main ranch house set, which may have been located near the site of today's Mae Boyar Park in Oak Park. (Bison Archives.)

STEINBECK COUNTRY. Director Milestone returned to the area to film his 1949 adaptation of John Steinbeck's *The Red Pony*. The movie, costarring a 7-year-old Beau Bridges (pictured in the middle on the horse), was shot all over the Hearst Ranch, including the area that would become Mae Boyar Park. Note what appears to be the same tree-lined Agoura Ranch hill in this photograph and in the one above from *Of Mice and Men*, shot by the same director 10 years earlier. (Bison Archives.)

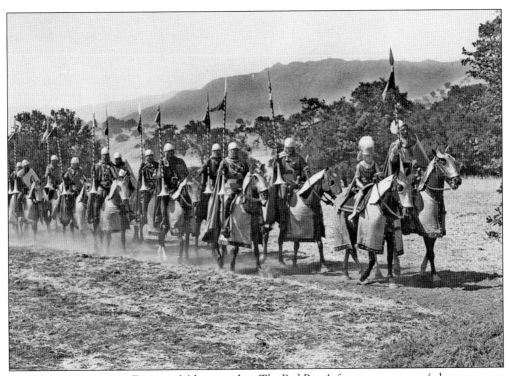

KNIGHTS OF LADYFACE. Director Milestone shot *The Red Pony*'s fantasy sequence (where a young boy dreams of being a knight) in the Agoura Valley with Ladyface Mountain as a backdrop. Milestone also chose the Morrison Ranch/Oak Park area to help recreate the Italian countryside for his Dana Andrews anti-war picture, *A Walk in the Sun*. He later shot his war movie, *Pork Chop Hill*, with Gregory Peck in the nearby Westlake Village area. (Bison Archives.)

ON LOCATION NEAR DEERHILL PEAK. The gentle rise on the right is a peak that can be found at the top of today's Deerhill Road. From left to right, Robert Mitchum, Peter Miles, and Louis Calhearn starred in the 1949 drama *The Red Pony* with a classic score by Aaron Copland. (Bison Archives.)

OAK PARK RAT PACK. In *Texas Across the River*, Rat Pack buddies Dean Martin and Joey Bishop (in redface as an Indian) and French star Alain Delon (left) get a sober awakening as they run from angry Indian extras and head towards the site of today's Beanscene Espresso coffeehouse. It's unclear whether or not the producers of this broad cavalry-and-Indians comedy understood they were shooting in a historic Native American site. (Bison Archives.)

CHARGE AT LINDERO CANYON. The sawtoothed Simi Ridge frequently appeared as southwestern terrain in Universal's Western movies, as pictured in this scene from *Texas Across the River*. The Oak Park area made a good double for Texas, with its creek, oak trees, and, in previous years, longhorn cattle. (Bison Archives.)

OAK PARK SHOWDOWN. Bad guy Henry Fonda closes in on wounded Jimmy Stewart in Vincent McEveety's classic 1968 Western, *Firecreek*. (Bison Archives.)

NEW MAN WITH A BADGE. Ed Begley Sr. confers with new sheriff Jimmy Stewart at the same location where *Firecreek* director McEveety also shot a *Gunsmoke* episode in the same year. (Bison Archives.)

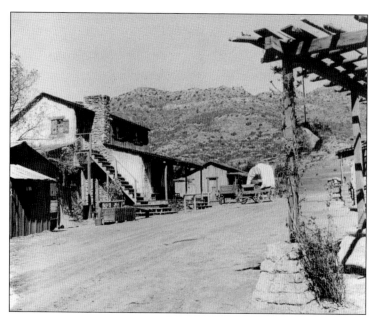

Western Town, 1966. This false-front Western town set, built near the intersection of today's Lindero and Kanan Roads and just below Simi Ridge, was featured in the Western spoof *Texas Across the River*. The set on the left side of the photograph was redressed years later, but the staircase remained, as can be seen in the photograph below. (Ed Lawrence.)

End of an Era. In this photograph, an Oak Park family plays among the shuttered film sets of North Ranch. "The old ghost town just deteriorated by the late 1960s," says resident Barbara De Minico. "People would scavenge anything they could find: large pieces of wood, prop doors, even a doorknob. It was just a shame, as it would have been nice to preserve it like the Western town at Paramount Ranch." (De Minico Family Archives.)

GOODBYE, HOLLYWOOD. According to longtime Oak Park residents, the movie ranch and its dilapidated false-front buildings were commonly known as the Ghost Town. The set was eventually torn down. (DeMinico Archives.)

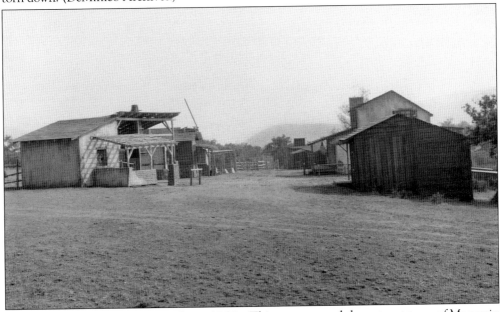

NORTH RANCH WESTERN TOWN, LATE 1960s. This set portrayed the outpost town of Moccasin Flat in the Dean Martin and Joey Bishop comedy *Texas Across the River*. This view of the town is facing south towards the Santa Monica Mountains. (Ed Lawrence.)

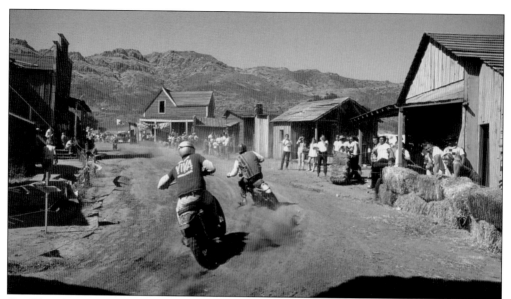

GET YOUR MOTOR RUNNING. The horses were gone, but there was plenty of horsepower when the cameras stopped rolling at the North Ranch set in the early 1970s. It was transformed into the Westlake Grand Prix for occasional events where motorcycle clubs, sponsored by the Stuntmen's Association, raced through the old Western town. (Ed Lawrence.)

LAST LOOKS. Former Indian brave Dustin Hoffman looks back en route to civilization driven by Rev. Thayer David in Arthur Penn's 1970 classic, *Little Big Man*, one of the last films shot on the Western town set. (Bison Archives.)

BAD DAD IN TRAINING. Christopher Mintz-Plasse teaches Paul Rudd some creative vocabulary at the Oak Park Shopping Center (built just south of the site of the old North Ranch Western Town movie set) in the 2008 comedy *Role Models*. (Bison Archives.)

INDOOR PLAY DATE. Adam Sandler, Jennifer Aniston, and kids head towards the Bright Child indoor play area and activity center in 2011's *Just Go With It*. (Bison Archives.)

Discover Thousands of Local History Books
Featuring Millions of Vintage Images

Arcadia Publishing, the leading local history publisher in the United States, is committed to making history accessible and meaningful through publishing books that celebrate and preserve the heritage of America's people and places.

Find more books like this at
www.arcadiapublishing.com

Search for your hometown history, your old stomping grounds, and even your favorite sports team.

Consistent with our mission to preserve history on a local level, this book was printed in South Carolina on American-made paper and manufactured entirely in the United States. Products carrying the accredited Forest Stewardship Council (FSC) label are printed on 100 percent FSC-certified paper.